DESIGNING DESIRE
TOWARDS AN AUTONOMOUS EDITORIAL PRACTICE

Dário Cannatà

Dissertation presented in partial fulfilment of requirements
for the degree of master in Graphic Design and Editorial Projects
in the Faculty of Fine Arts of the University Porto.

Dissertação para obtenção do grau de mestre
em Design Gráfico e Projectos Editoriais,
Faculdade de Belas Artes da Universidade do Porto.

Supervisor / Orientador: Professor Diniz Cayolla Ribeiro

Faculdade de Belas Artes da Universidade do Porto
Faculty of Fine Artes of the University of Porto

Porto, 2015

© 2015 Dário Cannatà. No rights reserved.
ISBN: 978-1-326-37966-7
Published through lulu.com

Quero agradecer ao meu orientador, o professor Diniz Cayolla pela disponibilidade cedida e clareza na discussão, ao Samuel pela sua atenta revisão final, à Ana e ao Óscar pela paciência, e sobretudo à Mariana e ao Lucas pela companhia durante todo o processo.

Para isto, não serve o Inglês.

Abstract

Designing Desire: Towards an Autonomous Editorial Practice is an attempt to establish a personal positioning within the polarised practice of graphic design, commonly divided between persuasion and communication. Through a general historical review focusing on the more recent advent of "critical design", the thesis argues for the necessity of developing an autonomous practice to recover the social dimension of graphic design.

Drawing from fields apparently distance from design, such as philosophy, chemistry or biology, we reach "memetics" as an evolutionary theory of mental content, capable of providing the necessary arguments to sustain a pertinent editorial design practice.

Resumo

Designing Desire: Towards an Autonomous Editorial Practice é uma tentativa de estabelecer um posicionamento pessoal dentro de uma prática polarizada de design gráfico, normalmente dividida entre persuasão e comunicação. Através de uma revisão histórica geral, com especial atenção para a recente emergência do "design crítico", a tese defende a necessidade de desenvolver uma prática autônoma de forma a recuperar a dimensão social do design gráfico.

Através da referência a disciplinas aparentemente distantes do design, como a filosofia, química ou biologia, chegamos à "memética" enquanto teoria evolutiva do conteúdo mental, capaz de fornecer os argumentos necessários para sustentar uma prática pertinente de design editorial.

5		Abstract
11	1.	Why Design?
17	2.	Historical Review
21	2.1.	The origins of graphic design
27	2.2.	A Polarized Practice
31	2.3.	Designer as Author
37	2.4.	Critical Design
41	2.5.	Critical Graphic Design
45	3.	Free from Form
47	3.1.	Beyond Critical Design
51	3.2.	Editorial Design
55	4.	Values for Communication
57	4.1.	*Spirit*
59	4.1.1.	*Zeitgeist* — Time
65	4.1.2.	*Genius Loci* — Space
69	4.2.	The Man-made *spirit*
69	5.2.1.	Bings
73	5.2.2.	Artificial as Natural
77	5.3.	Natural Culture
77	5.3.1.	Evolution
83	5.3.2.	Designing memes
87	6.	Towards an autonomous practice
97		Bibliography

"(…) do not let designers just become walking encyclopaedias, adorned with such titles as 'master', 'doctor' or 'professor', their qualifications dependent on a framed certificate hanging on the wall. Let there be a design practice in which the hypothesis – the proposal – has higher esteem than need and justification." (Velden 2006)

1.
WHY DESIGN?

With the growing democratisation of the graphic design field, brought up by the personal computer, the internet and the emergence of desktop-publishing, alongside with an increased notion of a political and ethical responsibility of designers, its current *status quo* can be said to be opened for debate. Furthermore, if we trace the origins of the theoretical grounds of design as a discipline within modernism, (or functionalism) and the subsequent postmodern critical stance, we can discern an increasing process of questioning, that despite providing various answers, as well as questions, is still struggling to provide significant substance to a field. This historical progression has defined graphic design as a discipline which is often laid out as having an "uncertain identity" and identified by a term that is "increasingly vague and useless"(Erlhoff 2008).

I am not talking about a conceptual fluidity or the impossibility of conceiving closed definitions, but rather I am referring to the current scission of the discipline in different, and often contradicting, approaches, resulting in the fact that a traditional definition of graphic design is no longer sufficient to define all the practices that it currently encompasses, and depending on the context, different conceptions can be identified. The specialisation of design as a discipline brought with it a self-consciousness that seems to make it difficult for designers to settle in their given compartment, normally connected to advertisement. The 2012 exhibition *Graphic Design: Now in Production*, curated by Andrew Blauvelt and Ellen Lupton, displayed work produced since 2000 fully portraying this scenario of multiple approaches. It followed the discourse of design through a long list of possibilities: the designer as author, as editor, as publisher, as producer, as entrepreneur, as programmer, as archivist, as visual journalist, as tool maker, as curator, as storyteller, as pedagogue, as artist, as researcher, and as enabler.

The understanding that "the organization of letters on a blank page – or screen – is the designer's most basic challenge" (Lupton 2004, p. 7) presupposes the notion that writing may itself be considered a practice of graphic design and possibly, a prediction for an "expansion of the graphic design field" (Blauvelt 2013). Graphic designers have clearly an intimate relation to text, but usually, they don't write the content themselves. Nevertheless, the history of visual

communication is deeply rooted in the development of the first alphabets through scribes and typographers, even if traditionally, this relation might have been exclusively formal[1]. Visiting the Portuguese National Museum of Press in Porto, I am told that typesetters, the workers that hand picked the movable types and composed them on the printing press were usually illiterate[2]. Scanning through a manuscript, they would identify the character exclusively through its shape and position on the type drawer without knowing the meaning created by the sequencing of the letters. The Modernist 'form follows function' motto would only widen this gap between form and content turning graphic designers into "arbiters of taste and dictators of physical forms" (Mitchell 1988, pp. 208-215). Eventually, this progressive specialisation of the field would create a "bibliographic explosion" with an unprecedented growth in design publications and magazines, exhibitions, conferences and seminars, workshops and also academic possibilities (Moura 2001, p. 15). Today, the idea of separating design from its content is thoroughly contested even if the dominant perspective is still strongly related to form.

Considering the academic nature of this document, a master thesis that would supposedly precede my entrance in the professional practice, I find it pertinent, if not urgent, to come to terms with these questions, being able to clearly state my judgments within the open debate. As a graphic designer, focusing on an editorial practice, how may I make sense out of this "uncertain identity", and above all, how can I define the principles to govern my practice?

Firstly, I must place myself — through a general historical review, I will summarise the steps leading to the current situation of pluralism and opposition

1. Which was not — for instance, the exquisitely printed book *Rigiomontanu's Calendarium*, a first application of Renaissance scientific methods of astronomical calculation and observation to the problems of the lunar calendar, printed in 1476 by Erhard Ratdolt, was, according to Megg's History of Graphic Design, "largely a result of Ratdolt's interest in mathematics and astronomy", suggesting an existing relation between the designer (so called printer at the time) and written content.

2. A common characteristic for most of the Portuguese population until the second half of the xx century (Candeias 1998).

within the design discourse, focusing on the developments of what is commonly referred to as 'Design as Author' and the more recent 'Critical Design'. This historical framework, together with an idea of the multiple ramifications of the contextually dependent design practice, without forgetting the in betweens of an oversimplified dichotomy between commercial and marginal, should provide some structure to the "increasingly vague and useless" term of graphic design. I will try to find clues for an historical reference on what the role of design might be, somewhere to place my own practice of editorial design.

Secondly, I must ground myself — having established a point of view, I must define my perspective. Through a series of arguments I will try to define a framework capable of following the paths proposed by the initial historical positioning as well as providing a solid ground to develop my personal disciplinary practice. Central to this stance is the idea of the immateriality of communication, unconstrained from its neighbouring disciplines, such as architecture and industrial design, which tend to focus mostly on the material consequences of their practice. It is an attempt to provided the needed substance for graphic design to have its own narrative.

Finally, I must grow — it is a happy coincidence that the requested assignment for the master in graphic design and Editorial Projects is a written thesis. Logically, I find it an opportunity, even a necessity, to view this editorial object as a proof of concept for the questions and ideas proposed within the thesis.

If the context of this thesis was architecture for instance, my focus would be exclusively related to the content of the object, the meaning of text. Form, and its relation to content, would be arbitrary, probably relegated to a series of rules institutionally dictated to convey academic uniformity. I would have no reason to give special attention to the process of developing the exercise as an editorial object, in this case a book, as there would be no immediate relation between my practice and the development of books. The conclusion of this work can therefore be seen in the materialisation of the book itself, an understanding only possible after reading it.

2. HISTORICAL REVIEW

"There are professions more harmful than industrial design, but only a very few of them. And possibly only one profession is phonier. Advertising design, in persuading people to buy things they don't need, with money they don't have, in order to impress others who don't care, is probably the phoniest field in existence today. Industrial design, by concocting the tawdry idiocies hawked by advertisers, comes a close second."

Victor Papanek, *Design for the Real World*, 1984

Graphic design, as a professional discipline, functions within a frustrating reality. Often misunderstood as advertising, it has not yet proven itself as an autonomous discipline capable of building its own narrative. Its discourse is often borrowed from neighbouring fields, and theories of communication seem difficult to grasp within a professional practice, which is usually governed by marketing strategies, discarding much of the aesthetics theories that are key subjects within graphic design education. Furthermore, it is increasingly splitting into different specialisations mainly through different market niches and platforms, giving the impression of a fragmented field. The few studios that manage to cover the different areas of graphic design are usually quite large and focus mainly on commercial projects. Advertising agencies manage to cover most of these branches, incorporating graphic design within their structure together with marketing, copy-writing, photography, film, etc. A design studio might be as small as an individual and yet, he will probably be doing advertisement. At the same time, years of academic background together with artistic and underground niches of graphic design exploration seem to provide an alternative approach to the practice, that besides providing critical insight towards the commercial application of design, it also poses an increased challenge to the definition of design.

Rick Poynor clearly identifies the contradiction that designers face. In a debate with Michael Bierut, he points out that "(...) any view of design which insists on pure objectivity seems to reduce us to machines (...) Advertising under-

stands this perfectly and increasingly plays up the emotional side. You tap into a person's desires. Design is hopelessly enmeshed in this now. Design is hugely persuasive." (Bierut 2004) Identifying the origins of design within advertisement, he makes this argument against the reactions of professional designers during the 50s and 60s, mainly through the *First Things First* manifesto (1964) who advocated a focus on the role of communication rather than that of advertisement. Clearly, money had been on the advertisement side, dictating a tight relation with advertisement, and designers who avoided such connotations could simply be denying reality. As Alice Rawsthorn put it "Money. Money. Money. It may not be a fashionable or romantic explanation for why good design matters, but it is undeniably persuasive, and has been throughout history." (Rawsthorn 2013, p. 62)

Nevertheless, she admits: "Yet design matters in many other respects too" (*Ibidem*); and despite Rick Poynor's opinion, the relation between design and advertisement has changed throughout history and different interpretations can be identified depending on the historical perspective. "Precisely what design means and how it is applied has differed from company to company, industry to industry, country to country and era to era, depending on the scale of the project, its technical complexity, legislative constrains, political sensitivity, and random factors such as whether the engineers tend to shout louder than the designers in meeting." (*idem*, pp. 18-19)

Different interpretations on the function of design, will suggest different readings of design's history.

2.1. THE ORIGINS OF GRAPHIC DESIGN

The idea of a persuasive practice didn't really exist since the initial stage of design practice, as advertisement is clearly a latter phenomenon, even if it expanded the field considerably. However, despite this contemporary image of graphic design, it seems relatively limited to define it as such. Richard Hollis's history of graphic design defines three clear roles of graphic design: identification; information/instruction; and presentation/propaganda. However, he establishes the work of the late 19th century poster artists as the precedent of what would come to be the practice of graphic design, suggesting a predominance of the third function – presentation and propaganda.

> "Poster artists of this period demonstrated the aesthetic freedom and creative daring that accompanies the first confrontation with new technical innovation in graphic production and reproduction. When artists instead of adding text with printer's type, drew the lettering themselves, and when they were responsible for each element in a design which was intended for reproduction by machine, they were practicing what was later to become recognized as graphic design." (Hollis 2001, p. 16)

However, his account leaves out much of the previous history of graphic design, misinterpreting more significant origins for the practice. As he argues, if we consider that graphic design is characterized by the fact that artists drew their typefaces and were responsible for each element to be reproduced by a machine, then we must acknowledge the work that Gutenberg developed, more than 400 years before the so called "poster artists", as an earlier approach to this conception. Besides, during those 400 years, the *Incunabula*, in the Renaissance and the Enlightenment periods, a lot of work was developed that certainly questions the definition of Design as advertisement. Richard Hollis mentions Gutenberg's 1455 *42-line Bible* with a single image, representing the page structure of the book, and it's corresponding subtitle, dismissing a major account of what was necessary in the creation of typographic printing. In fact, his book is honestly entitled as *a concise history*, and we may acknowledge that his conception of the origin of design within advertisement might just be a limited one.

Meggs's History of Graphic Design is considerably more elaborate, drawing a conception of graphic design that dates back to the first examples of prehistoric visual communication: "The development of writing and visible language had its earliest origins in simple pictures, for a close connection exists between the drawing of pictures and the marking of writing. Both are natural ways of communicating ideas, and early people used pictures as an elementary way to record and transmit information." (Meggs & Purvis 2011, p. 6)

Johanna Drucker and Emily McVarish's History of Graphic Design follows the same steps as Philip B. Meggs. "Stone Age artists established the basic conventions essential to graphic design as early as 35,000 years ago. These foundations are now so familiar that they are taken for granted." (Drucker & McVarish 2009, p. 3)

Despite acknowledging the intrinsic relation of graphic design to communication, instead of persuasion, both authors are clear about the contemporary roots of design being settled around the same time that Richard Hollis refers to.

> "The Industrial Revolution generated a shift in the social and economic role of typographic communication. Before the nineteenth century, dissemination of information through books and broadsheets was its dominant function. The faster pace and mass-communication needs of an increasingly urban and industrialized society produced a rapid expansion of jobbing printers, advertising, and posters. Larger scale, greater visual impact, and new tactile and expressive characters were demanded, and the book typography that had slowly evolved from handwriting did not fulfil these needs.
>
> It was no longer enough for the twenty-six letters of the alphabet to function only as phonetic symbols. The industrial age transformed these signs into abstract visual forms projecting powerful concrete shapes of strong contrast and large size. At the same time, letterpress printers faced increasing competitive pressure from lithographic printers, whose skilled craftsmen rendered plates directly from an artist's sketch and produced images and letterforms limited only by the artist's imagination." (Meggs & Purvis 2011, p. 145)

However, this conception might be seen more as an expansion of the design field rather then the birth of what would become known as Graphic Design.

> "The letterpress printers turned to the typefounders to expand their design possibilities, and the founders were only too happy to comply. The early decades of the nineteenth century saw an outpouring of new type designs without precedent." (*Ibidem*)

This moment might be paralleled with other periods, mapping the progressive expansion of the practice. During the Renaissance, the advent of Gutenberg's letterpress printing would foster the impact of editorial material, previously mainly confined to religion, to all cultural spheres such as science, medicine, art, history, cartography, weaponry, etc. (Drucker & McVarish 2009, pp. 70-90) The following centuries would see this role of print fully established: "Enlightenment thought was shaped by the use of print to disseminate information, manage power, and minister resources." (*idem*, p. 115) The consequences of this service, would again expand the functions of printed material with the inevitable advent of industrialization. With the dissemination of printed matter, so did the values that they portrayed: "The era was characterized by a commitment to social and technical progress, a conviction that scientific knowledge should be freed from religious doctrine, the establishment of democratic forms of government, and the rise of markets that generated – and were dependent on – the flow of capital." (*Ibidem*)

The changes brought up by the industrialization can therefore be thought of as a new field of graphic design, rather than its defining characteristic. However, this new and expanded role would have dramatic changes in the practice. "As industrialization expanded, more designers were hired, the demands on them became more onerous and their roles more rigid. Design teams grew larger and more hierarchical. The historic division of responsibility between design and other disciplines, such as engineering, was formalized, and the friction between them escalated as the competing camps jostled for power." (Rawsthorn 2013, pp. 37-38)

From William Morris to the Bauhaus, the definition of design drifted from the contradiction to the acceptance of industrialization. The works developed during the Arts and Crafts movement would claim a return to craftsmanship, as a conscious critical stance towards the English tendency for industrial production and commercial purposes, responsible not only for poor labouring and inhabitance conditions, but also for the lack of quality of the objects that were being produced. This implied a return to an earlier conception of design, rowing against the tide of rationalism that powered the industrial revolution. However, this vision would not stand as the attention to an "organic unity, spiritual integrity, and material honesty" (Drucker & McVarish 2009, p. 182) would be inevitably absorbed by industrial production, replacing the processes that tried to imitate the previously manufactured objects with a renewed language in consonance with the mechanical spirit. "The paradox of William Morris is that as he sought refuge in the handicraft of the past, he developed design attitudes that charted the future. His call for workmanship, truth to materials, making the utilitarian beautiful, and fitness of design to function are attitudes adopted by succeeding generations who sought to unify not art and craft but art and industry. Morris thought that design could bring art to the working class, but the exquisite furnishings of Morris and Company and the magnificent Kelmscott books were available only to the wealthy." (Meggs & Purvis 2011, p. 183)

As things progressed, balancing the social function of design proposed by Ruskin and Morris with the consequences of industrial enterprises became increasingly more difficult. The beginning of the 20th century would see the establishment of advertisement as design's most professionalized role. Laszlo

Moholy-Nagy and Jan-Tschichold together with Josef Albers, Georgy Keps, and Herbert Bayer would bring the integrity of design with modernity even closer as they took the education model of Bauhaus to the Unites States and Switzerland while fleeing from Nazi Germany (Meggs & Purvis 2011; Drucker & McVarish 2009).[1]

By that time graphic design had already achieved its central position within the market economy. In 1917, the Association of American Advertising Agencies, in 1920 the Art Directors Club in New York, and in 1931, The American Marketing Association were founded. By 1937 the New Bauhaus was also founded in Chicago enjoying the prolific environment for the establishment of modernism, not only within communication, but also in art, architecture, cinema, even fashion.

This modern conception of design was grounded on the synthesis between art and industry, a tendency commonly represented through the architect and designer Peter Behrens and his work for the AEG company in Germany during the first decade of the 20th century. With Bauhaus, this disposition took the important steps of defining a "universal language" of visual communication based on values of clarity, rational organization, and functional efficiency.

After the 2nd World War, graphic design was deeply entangled with the objective of economic prosperity by developing brands and identity that would allow the corporate culture to thrive, building a world of consumerism that would overrun the social functions of design. The font *Helvetica* would embodied this conception. Drawn in Switzerland 1954 by Max Miedinger and Eduard

1. Curiously, Tschichold would later reject his own earlier developments, mainly manifested by his 1928 book, *Die neue Typographie*, claiming that the "new typography's 'impatient attitude conforms to the German bent for the absolute, and its military will to regulate and its claim to absolute power reflect those fearful components of the German character [that] set loose Hitler's power and the Second World War." (Meggs & Purvis 2011, p. 338) His later work would approach the humanist tradition, borrowing from the work of past typographers such as Roman inscriptions, Baskerville or Bodoni, and advocation freedom of thought and self-expression. (*Ibidem*)

Hoffmann, it was intended to be a neutral typeface characterize by clarity, no intrinsic meaning in its form, and the flexibility to be used on a wide variety of signage. (*Helvetica* 2007) [2]

Throughout the 20th century, as the economic paradigm shifted from production to distribution, graphic design would acquire an increasingly relevant position in the "cultural apparatus". With an increased international validity, it would also give rise to an academic culture capable of spreading the prevailing graphic style in advertising, editorial art direction, and corporate communications. These institutions would focus on the *international style* promoting the Bauhaus methodology. In 1910 the School of Applied Arts (*Kuntstgewerbeschule*) was founded by Ernst Keller in Zurich; in the 1950s Max Bill together with Olt Aicher and Inge Aicher-Scholl, would establish the Institute of Design in Ulm, Germany. "Educational programs institutionalized design doctrines to an unprecedented degree in the 1960s" (Drucker & McVarish 2009, p. 265) and eventually "modernism had become mainstream, losing its political claims and innovative edge in the process" (*idem*, p. 276).

The chain of events, from the reactions of William Morris and John Ruskin towards industrialization, to the internationalization of a single style, would represent "the last gasp of modern utopianism (…) channelled into the neutral-seeming surfaces of a universal style system that served private interests with seamless efficiency" (*idem*, p. 182), building a conception of design as a practice detached from the social implications of capitalist consumer culture.

Modernism would represent a significant or even dramatic expansion for the practice of design, and despite influential, it didn't necessarily erase the previous functions of visual communication. Again: "the expansion of the graphic design field isn't solely predicated in the expansion the various forms that it might take, but rather on the appropriation and the blurring of boundaries between different practices that graphic designers take in." (Blauvelt 2013)

2. Interestingly, Helvetica would be a revival of the font Akzidenz-Grotesk, one of the first sans serif fonts to be widely used, released around the same time of the initial progress of industrialization, by the Berthold Type Foundry in Germany 1896. (Kupferschmid 2012)

2.2. A POLARISED PRACTICE

Eventually, voices of protest started to emerge that would contradict this tendency towards commercial work trying to focus on more pertinent roles for design. During the 60s, the American architect, systems theorist, author, designer, and inventor Buckminster Fuller would develop the idea of "the comprehensive designer" with a strong influence into trying to bring the political responsibilities of design back into the practice: "The specialist in comprehensive design is an emerging synthesis of artist, inventor, mechanic, objective economist and evolutionary strategist. He bears the same relationship to society in the new interactive continuities of world-wide industrialization that the architect bore to the respective remote independencies of feudal society" (Fuller 2010, pp. 232-233). He "will be accepted by the industrial authority because the latter has recently shifted from major preoccupation with exploiting original resource to preoccupation with keeping the 'wheels', which they manage turning. (…) World-industrial management will be progressively dependent upon the Comprehensive Designer to accelerate the turning of his wheels by design acceleration. (…) An answer as to whether the designer will be credited by political leadership has been made. Political leadership in both world camps has announced to the world of potential consumers their respective intents to up the standard of living of all world peoples by 'converting the high technical potential to account through design.' (*idem*, pp.238-239).

Bucky's challenge would have a strong resonance with the design community, as American industry progressively shifted from production, to a services, focusing on development of brands and moving the production process to underdeveloped countries with cheap labour. "The medium is the message", coined by Marshal McLuhan in 1964 would manifest the self-consciousness resulting from the new role of media and branding.

Despite these efforts, and those of other designers, the demands of the market dictated a different kind understanding of design and much of the celebrated design would be referenced to this type of work, rewarding a culture of design mainly dependent on the economic success of its clients. "Public perceptions

of design were dominated by the flamboyant personas" like "Raymond Loewy (…) responsible (he or his team were) for the design of the Greyhound bus, the Lucky Strike cigarette packet, a Coldspot refrigerator, the Coca-Cola bottle and logos for Shell and Exxon, among other things. In 1949, he became the first designer to appear on the cover of Times magazine. (…) 'Asides from wanting to make a living, we are all nice fellows,' he said of himself and his fellow industrial designers. 'Outré at heart and simple enough to believe that by improving a product functionally, safely, qualitatively and visually, we were contributing something valuable to the consumer, his sense of aesthetics and to the country'." (Rawsthorn 2013, pp. 37-40)

This neutral positioning is still strongly present within the different discourses and media such as the press, magazines, lectures or education institutions. Regarding the history of design as a succession of prominent designer-heroes, provides a distorted view on the full potential of graphic design mainly mediated by the very same ideological system that promotes that kind of discourse. During an interview in 2010, Paula Scher would state:

> "(…) Most of my clients don't think in terms of 'social responsibility'. They think in terms of profit, or if they are a not-for-profit, they think in terms of success, meaning getting people to go to their museums or plays, etc. If a designer is 'socially responsible', that's nice. The next question is, will it help them sell their products or get people to go to their museums, etc., without costing them anything extra?
>
> The client's real responsibility to themselves is to keep themselves going, so they can grow and create wealth, which ultimately means employing people, and contributing to the general economic health of society. We need this. It makes for a better society. I like full employment. Of course they shouldn't cheat, steal, pollute, etc. But if they are looking for intelligent ways to compete to make their businesses successful, and they are hiring people as result of it, they are heroes in my book."

The well known *First Things First* manifesto, brought up by Ken Garland in 1963 was probably the most disseminated reaction from a part of the graphic design community to the ever increasing legitimization of the profession as a service industry for organizational and business interests. It claimed "a reversal of priorities in favour of the more useful and more lasting forms of communication" (Various Authors 1964), representing an early worried view of how graphic design in particular was loosing its focus from the social function of communication, to the capitalist function of consumerism.

"The critical distinction drawn by the manifesto was between design as communication (giving people necessary information) and design as persuasion (trying to get them to buy things)." (Poynor 1999) The dilemma was obvious. If a designer considers that the excessive consumer culture is damaging to the people who he is supposedly communicating to, why should he cooperate to persuade those people to participate even further on that culture. If the purpose is to inform, then shouldn't designers, through their capacities, warn people about the problem? Indeed, as demonstrated through Raymond Loewy and Paula Scher, the commonly celebrated designers are usually those who came to terms with these questions.

On 1999, the manifesto would be republished with a few modifications under the name *First Things First* 2000. The priorities had not changed, and the gap between the distinction had only widened. "With the explosive growth of global commercial culture, their message has only grown more urgent." (Various Authors 2000)

The original manifest proved inconsequential given its goals, and so did the revised edition. However, the accentuated division would underpin the idea that design shouldn't be neutral:

> "Consumerism (…) must be challenged (…), in part, through the visual languages and resources of design." (*Ibidem*)

While the subscribers of the second manifest appealed for action, the first one dismissed any political issue claiming that an abolition of "high pressure consumer advertising" was not their intention as it wouldn't be feasible, holding to the idea that the *status quo* of Design could be maintained as neutral and objective as the moderns had insisted.

The manifesto would be an influential agent within counter-culture consciousness among design professionals, revealing the dividing forces central to the difficulties in defining the practice, and marking a "political and cultural shift of design (…) towards the interests of the public sphere, suggesting that its practitioners, although associated with the business world, they have the political, ethical and social competences necessary to represent public interests. This change of identity on behalf of design wouldn't be either cosmetic, nor consensual, but it would drastically modify it as a discipline, and above all, the way how their practitioners positioned themselves within it and in relation to their clients."[3] (Moura 2001, p. 20)

Bruce Mau, one of the most celebrated designers of the 21st century, would say of the manifesto:

> "FTF2000 was a struggle with the social and political dimension of design. But not a victory. Under that manifesto lies the faulty logic that somehow there is a 'clean' and 'pure' design practice that is free from the compromises of the market; that big organizations are bad; (…) We live in a network economy. There are no longer discrete entities. All objects, practices, organisms, gestures – and clients – are woven into an infinitely complex web of relations. (…) The ideas of FTF2000 are from another era, the era in which it was originally conceived, the sixties. What we need today is full fledged engagement. Forward, not reverse." (Bruinsma 2004)

Nevertheless, the influence of the manifest was clear. As Bruce Mau noted: "Design takes on a social dimension." (*Ibidem*)

3. Translated from Portuguese.

2.3. DESIGNER AS AUTHOR

The emerging "design community", already present during the first edition of the FTF manifesto, would demonstrate that "as a practice, design is no longer an activity that exists only in relation to an exterior client – as a service –, but rather it becomes a self-conscious subject, whose mechanisms, so far internal, have earned a public of their own"[4] (Moura 2001, p. 33), eventually embracing the possibility of abandoning the task of communication "in favour of critical reflection and a deliberate dismantling of the rules of the game" (Drucker & McVarish 2009, p. 317). With the increased self-awareness of design, "the curious, often reverse complicity of designers with societal forces with which they felt at odds became a topic of conversation and debate, even as the industries that absorbed students from design programs expanded in variety and scale. Designers seemed increasingly sensitive to the role they played in promoting consumer culture" (*Ibidem*). Besides, the will to position design more favourably compared to activities with wider public recognition such as architecture, art, literature or cinema, and the attempt to detach design from the modernist logic of functionalism[5], reclaimed an increased participation of designers in the process of creation and edition of content, as well as the possibility of a political and ethically involved practice. (Moura 2001, p. 33)

In 1992 Alan Fletcher, one of the initial founders of Pentagram, after working for decades within the highest standards of commercial context, would retire to his home in England and continue to work on design without the tensions of the corporate culture. During this time, he developed the seminal book *The Art of Looking Sideways* that besides showcasing some of his work, consists of an eclectic visual feast spanning over 1000 pages, gathering ideas, quotes, short stories, history, influences, riddles, and other diverse contents, in a prolific

4. Translated from Portuguese.

5. "Thus it becomes clear that the representation of function as neutral – which is, after all, necessary for 'form follows function' to define itself as a clear guiding principle – is an illusion; the logical consistency it was supposed to provide for design is no longer tenable." (Erlhoff 2008, p.179)

exploration through the language of visual communication seen through the eyes of Alan Fletcher. The book took 18 years to finish. It represented not only a detachment from the commercial ties of design, but also the possibilities of authorship within the practise.

The book *Life Style*, authored by Bruce Mau in 2005, can be seen as an extreme take on this position. Also quite large in size, with more than 600 pages, it presents a recollection of the work developed by Mau with commentaries to the different relations between clients, the studio, and working methodologies. This analysis provided the possibility for a critical awareness of the role of the studio between the commercial and cultural contexts, being capable of going further than the implications of Fletcher's book: "rather than passively decorating the world, the book argues for a kind of design that actively shapes it – that 'styles life'." (Baily 2001)

Other designers, through publications, conferences and exhibitions, would follow the trend giving substance to the idea of authorship within design practice. This tendency would be embodied by the term "Designer as Author", an analogy that gained significance with the article *The Designer as Author* by Michael Rock, first published in Eye magazine in 1996. It was the first attempt to understand the idea of authorship within the practice of graphic design, pointing to the possible main theoretical influences that sustained an authorial approach in design, such as Roland Barthes' *Death of the Author* written in 1967 suggesting that the death of the author would be the birth or the reader, or Michel Foucault's *What is an Author?* written in 1969 as a response to Barthes' theory, deepening the notion of author as a social construction that reflects the ideological relations between the processes of disseminating knowledge.

Despite presenting numerous cases where authorship could be applied, admitting the increased relevance of graphic authorship within the practice, Rock is critical of the theory that supports it and dismisses it as a form of legitimization.

> "While some claims for authorship may be simply an indication of a renewed sense of responsibility, at times they seem ploys to gain proper rights, attempts

to exercise some kind of agency where there has traditionally been none. Ultimately the author equals authority." (Rock 1996)

His conclusions aren't entirely wrong. Within a post-industrial economic context, as corporate culture changed its focus to branding instead of production, designers simply followed the same steps. What could have started as a reaction against mainstream graphic design, manifested in the idea of authorship as a self-conscious act of managing content ended up, in many cases, as a legitimizing tool for an enhanced position within an increased competitive environment.

Just as Fletcher had left Pentagram in 1992, in 2009 Bruce Mau sold his company (Bruce Mau Design) and started the "Massive Change Network" with his wife, dedicated to consulting, publishing and training. It is self-described as a global design learning network developing a global network committed to inspiring, connecting, and empowering entrepreneurial designers. The actual work developed by Massive Change Network is difficult to determine. Instead of acting as a traditional design firm, there is no portfolio. By claiming the role of "consultancy", Bruce Mau seems to have achieved a liberation from the physical constrains of design. The only significant information on their website is Mau's calendar of presentations, demonstrating an active agenda to develop workshops, presentations and conferences building the notion of a design guru. Through some news articles, we can follow the activity of Bruce Mau. He has been working with large corporations on issues that transcend the traditional roles of graphic design. By putting dozens of young designers together with the company stakeholders, he commands, with his wife, an oriented brainstorm session intended to provide fresh solutions to complex problems as well as a learning experience for the participants. (Sisson 2015)

The shift that Bruce Mau embodies from the 1985 somewhat traditional role of graphic designer for Zone Books, to the design guru of 2015 demonstrates how significant the idea of authorship might be to understand the expansion of graphic design within the 21st century. Authorship has provided the necessary brand effect that sustains his current activity, arguing for the legitimizing function of authorship. The way how the Massive Change Network website

refers to him is suggestive of this, presenting his *Incomplete Manifesto for Growth* as well as the books he authored and co-authored. However, if we refer to his reaction to the FTF manifesto back in 2004, the position he has acquired is somehow coherent with critiques he pointed to the illusory idea of a "'clean' and 'pure' design practice that is free from the compromises of the market" (Bruinsma 2004).

After Rock's article, others design critics wrote about the subject expanding the discussion through different perspectives. Ellen Lupton, Katherine and Michael McCoy, Steven Heller, Rick Poynor, Hal Foster, Stuart Bailey are some of the design critics that would further develop the idea of authorship, giving it considerable international exposure through graphic design magazines and websites such as Eye, Emigre and Design Observer[6].

As we approach contemporaneity, we abandon history and confront the present, leaving behind an apparent clarity that gets blurred with a multitude of references not yet filtered by time. Conclusions are more difficult to reach but we can see patterns that blend with the past, suggesting a possible approach to the future. The division between a commercial and an artistic design practice has become increasingly deeper. If Renaissance graphic arts could be attributed to a relatively small amount of functions, the same would be impossible for contemporary graphic design, and the proliferation of approaches fully established the idea of design as an undefined field. The emergence of authorship within graphic design could be understood as a consequence of this vagueness, trying to reclaim a position trough the subjective manifestation of the author. It is of no surprise that some books, such as *The Art of Looking Sideways* or *Life Style*, tend to combine portfolio-like representations of developed work, with statements regarding the author's opinion towards design itself or art, architecture, cinema, politics, urbanism, technology, etc.

6. The second chapter of Mário Moura's doctoral thesis, as far as I know, only available in Portuguese, provides a thorough analysis of the main contributions to the development of the idea of authorship within design.

Historically, the matter of "Design as Author" could be considered as settled as a reference to the developments within graphic design practice and theory from the 70s trough the 90s. However, this discussion would have a lasting influence on later developments. Simultaneously, different developments within architecture and art, reacting to the same social movements as graphic design, would provide a denser framework for the following moments of graphic design history, most notably, the idea of critical design.

2.4. CRITICAL DESIGN

In 1999, Anthony Dunne published the book *Hertzian Tales: Electronic Products, Aesthetic Experience, and Critical Design*, presenting "a space between fine art and design, showing how designers can use fine-art means – provoking, making ambiguous, making strange – to question how we cohabit with electronic technology and to probe its aesthetic potential". (Smith 1998) This would be first time the term "critical design" was used. It would be further developed in the book *Design Noir: The Secret Life of Electronic Objects*, written together with Fiona Raby.[7]

Later in 2013, Dunne & Raby would publish the book *Speculate Everything: Design Fiction, and Social Dreaming*, further establishing the presence of critical design. Essentially, it is an update on the term, but also a catalogue of recent works that might be considered critical, drawing from different contexts such as applied arts, graphics, fashion, furniture, vehicle, architecture, cinema and literature. Besides showcasing projects from different areas and authors, they used examples from their own design practice, as well as their former students at the Design Interaction course at the Royal College of Art, where they taught since 2005 until the beginning of this year, abandoning the position in order to fully dedicate themselves to their design practice. If *Hertzian Tales*, drawing from the past, was more of an historical validation to the practice of critical design, *Speculate Everything*, drawing from the present, would be its confirmation.

Due to the nature of their work, most of their projects would emerge through to the traditional objects of industrial design such as tools, furniture or technological devices, using them as elements for creating new interpretations and critical insight towards the relations between these objects and society. The project *Park Interventions*, commissioned by the influential Hans Ulrich Obrist in 2000 for the Medici Garden in Rome, presented a "collection of adult

7. Dunne and Raby's background is industrial design and architecture respectively. Both did research in Computer Related Design in the Royal College of Art – in the same institution where they would later teach –, Anthony Dunne as a PhD and Fiona Raby and MPhill.

furniture" that posed different questions: "During the day happy families play out idealized scenarios of modern life, while at night, they become sites for a variety of illicit activities. Our furniture will make some of these night-time activities more convenient and at the same time, offer a critique of the kind of design that is always trying to make things nice, convenient, user-friendly, efficient and ergonomic (especially public furniture)." (Dunne & Raby 2000).

In 2007, they published the *Critical Design FAQ* (Frequently Asked Questions) on their website, a text that can be read as a manifesto, but in the shape of a questionnaire. Written in a technical manner, with clarity and objectivity (cleverly presented as a FAQ), it presents the main principles of "Critical Design". A few points are worth quoting:

"1. What is Critical Design?

Critical Design uses speculative design proposals to challenge narrow assumptions, preconceptions and givens about the role products play in everyday life. It is more of an attitude than anything else, a position rather than a method. There are many people doing this who have never heard of the term critical design and who have their own way of describing what they do. Naming it Critical Design is simply a useful way of making this activity more visible and subject to discussion and debate.
Its opposite is affirmative design: design that reinforces the status quo.

2. Where did it come from?

Design as critique has existed before under several guises. Italian Radical Design of the 1970s was highly critical of prevailing social values and design ideologies, critical design builds on this attitude and extends it into today's world.
During the 1990s there was a general move towards conceptual design which made it easier for noncommercial forms of design like critical design to exist, this happened mainly in the furniture world, product design is still conservative and closely linked to the mass market.

(...)

10. But isn't it art?

It is definitely not art. It might borrow heavily from art in terms of methods and approaches but that's it. We expect art to be shocking and extreme. Critical Design needs to be closer to the everyday, that's where its power to disturb comes from. Too weird and it will be dismissed as art, too normal and it will be effortlessly assimilated. If it is regarded as art it is easier to deal with, but if it remains as design it is more disturbing, it suggests that the everyday as we know it could be different, that things could change." (Dunne & Raby (2007)

This initial setting of Critical Design, as defined by Dunne and Raby, presents a difficult analysis if we are to understand its pertinence with the field of graphic design. Considering the influences that Dunne and Raby present – the Italian movement of Radical architecture and the introduction of conceptual art within design –, we find references that are not very common to the discourse of graphic design, as suggested by the authorship thesis. Nevertheless, we can understand some common ground. "The 'counter-design' movement, centred on the work of Ettore Sottsass in Milan and on the Florentine Archizoom group, based itself on real, human concerns, on actuality and democracy; it took account of the violence of society, including the violence of production" (Burkhardt 1988, pp. 145-151). This positioning strongly relates to the same reactions that graphic designers were claiming with the first edition of the *First Things First* manifesto in 1963, with the difference that one happened in Italy, and the other in England, representing different interpretations towards post-modernism and the disenchantment of functionalism.

Nevertheless, the strict separation from art seems more contradicting than the previous point. Critical design, trough its refusal to play within the industrial context, manifests itself mainly through exhibitions, academic works and publications. The institutions that mediate the dissemination of this practice are the same institutions that function as the traditional validators of art. Furthermore, by borrowing the methods and approaches of art, the projects

end up revealing an indistinguishable similarity to a work of art. Just because it would be preferable to see critical design as something else besides art, it doesn't mean that it is so. Rather design borrowing from art, it seems more the other way around. Just as art incorporated photography, film, performance, music, literature and architecture, it might very well be introducing design to the collection. Although I understand the necessity to relate to real and pragmatic situations, this conception seems to be supported by a biased conception of art, trying to remain faithful to an academic and professional discourse. This optimistic tendency, tends to put aside a critical analysis of the context and emergence of critical design. Hence, the following accusation could be admitted: "Speculation is a way of maintaining proper politics while admitting defeat, a way to clear conscience on issues too big for design to tackle. It is solutions without the possibility of implementation, a criticality with built in safety from critique". (DuVall 2014)

Rick Poynor would agree, suggesting that "if critical graphic design is more than an aloof intellectual pose, it should spend less time hanging out with artists, turn its intelligence outward, and communicate with the public about issues and ideas that matter now." (Poynor 2008) This opinion however, seems unfair, not only to design – by denying it an introspective moment –, but also to art – dismissing the artistic practice as inconsequential and detached from daily life.

2.5. CRITICAL GRAPHIC DESIGN

> "The growing interest in critical design can be seen in a number of exhibitions dealing with this emerging genre – "last year's crop included 'Don't Panic: Emergent Critical Design' in London and 'Designing Critical Design' in Belgium. Strangely, neither addressed graphic design." (Twemlow 2008)

Slowly but steadily, graphic design would embrace this trend, providing a continuation for the discussion of authorship and the polarized practice. The 2007 exhibition *Forms of Inquiry: the Architecture of Critical Graphic Design* would be the first influential introduction of the term to graphic design. The exhibition was curated by Mark Owens, an American designer, writer, and filmmaker, and the Architectural Association art director, Zack Keys, a Swiss-American. It presented the work of "a group of contemporary, international graphic designers who base their work in critical investigation", featuring "works that have originated as self-propelled inquiry, either professional or personal, and have been developed into a myriad of media and forms." (Kyes & Owens 2007)

The article *Critical Graphic Design: Critical of What?*, written in 2014 by Portuguese designer and writer Francisco Laranjo, pointed to the fact that "the meaning of the word 'critical' in relation to graphic design remains unclear, resulting in an overuse and misuse in design magazines, books and websites." (Laranjo 2014) Moreover, he acknowledges a recent "disenchantment and even scepticism towards graphic design work that is labelled as critical" (*Ibidem*) with reference to a few online parodies such as Michael Oswell's satirical electro track *The Critical Graphic Design Song* that absurdly repeats the names of designer Zak Kyes and Radim Peško, whose typefaces Kyes often uses in his work, or the *Critical Graphic Design* tumblr page, an open-submission website filled with humorous content aimed to collect parody around critical graphic design.

However, Laranjo is relatively positive about the term, understanding the historical progression from the discussion of authorship: "The term also highlights an important transition in graphic design practice and education: from the

designer as author to the designer as researcher. This is not only a consequence of the maturation of the discipline, seeking legitimacy to be used as an investigative tool, but also the result of an increased importance of the social sciences, humanities and their multiple research methods being applied, changed and appropriated by design education and designers." (*Ibidem*)

Alice Twemlow wrote the first critical essay on the exhibition. Despite a superficial overview of the exhibition, she points to the difficulties of graphic design to respond to a critical practice. Suspicious of an "intuitive investigation", claimed by *Forms of Inquiry* curators in the exhibition catalogue, she dismisses most of its works as graphic design that "verges on introspection and obscurity". (Twemlow 2008) She only refers to the work of Metahaven with more consideration, judging that they actually researched their subject instead of just referring to it. This may very well be a biased point of view considering Alice's background as a researcher. Nevertheless, her questions remains: can the practice of graphic design itself be an investigative tool?

Metahaven, the Amsterdam design studio of Daniël van der Velden and Vinca Kruk, is probably the most influential team within critical graphic design. Self-described as a studio for design, research, and art, they have been pushing the boundaries of the practice not only through the appropriation of different approaches towards design, such as self-initiated publications, speculative identities, articles or videos, but mainly through the advocating a deep critical analysis of the role of graphic designers. Through their publications and teaching, they have been the Dune and Raby of critical graphic design.

Despite the differences between their approach, critical design has reached a common ground, demanding a necessary detachment from traditional roles of design as an agent of commercial persuasion, but also an autonomy for a self-reflexive practice: "With the removal of need and the commissioned assignment as an inseparable duo, the door is open to new paths. The designer must use this freedom, for once, not to design something else, but to redesign himself." (Velden 2006) "This kind of design can only exist outside a commercial context and indeed operates as a critique of it" (Dunne 2008, p. 84).

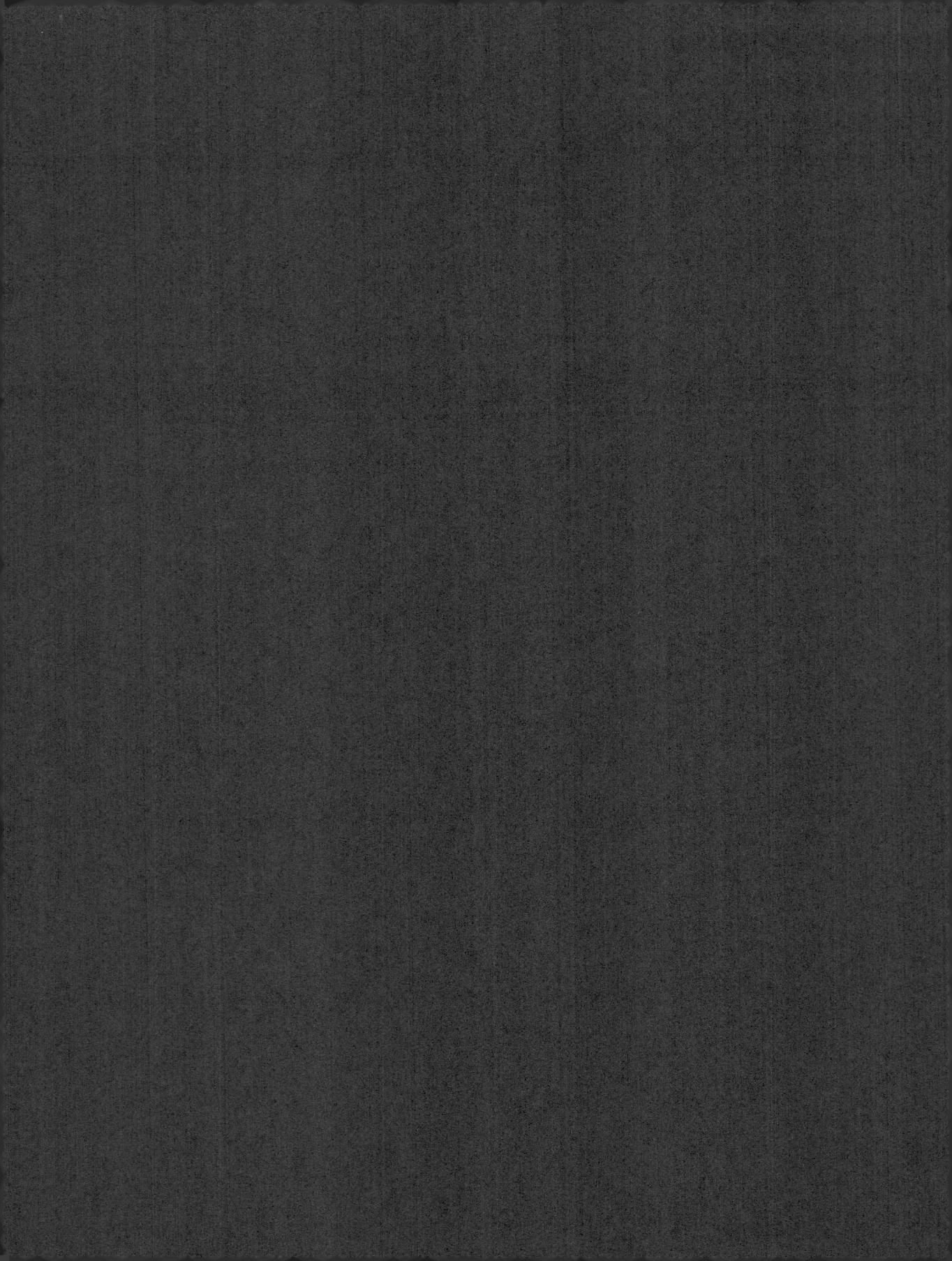

3.
FREE
FROM
FORM

The mission of redesigning design itself, proclaimed by Daniël van der Velden, could be understood as a necessity for design to acquire a language of its on, distanced from the functionalism model and the commissioned neutrality. After the FTF manifesto, and the advent of authorship within design, critical design seems to propose a continued effort in redefining this language. With the consciousness that "the 'total design' of the past is now the dispirited mandate of the 'look and feel'" (Velden 2006), the task is that of rediscovering the spirit.

3.1. BEYOND CRITICAL DESIGN

Despite being born from the Modernist context, between architects and product designers, graphic design presents itself in a radically different context. Besides, being a relatively recent specification of design, at least as a nomenclature, it doesn't share the complex and coherent language as older and more established practices such as fine arts, architecture or product design. Dealing with the social dimension of language, signs, representations and communication, the framework of graphic designer is significantly opposed to other disciplines dealing with physical matter.

> "Until recently, our world-environment consisted of things: houses e furniture, machines and motor vehicles, clothing and underwear, books and pictures, tins and cigarettes. (…) The information that now floods our environment displacing the things in it is of a kind that never existed before: it is immaterial information. The electronic pictures on the television screen, the data stored in our computers, all the reels of film and microfilm, the holograms and programs, are such 'soft' ware that any attempt to grasp them is bound to fail. (…) Indeed, we will realize that our attempt to get hold of things in life is not the only wise *modus operandi*, as we believed, but that our 'objectivity' is something relatively recent. We shall also notice that we can live differently, actually, maybe better. Moreover, 'modern' life, life surrounded by things, is not the absolute paradise that perhaps our parents thought it would be. Many non-Western societies of the Third World seem to have good reason to refuse it. If our children are also starting to refuse it, we should not

necessarily despair. On the contrary, we have to try to imagine this new life surrounded of non-things. (...) It must be admitted that it is no easy task." (Flusser 1993, pp. 85-89)

As Vilém Flusser suggests, it is important to come to terms with this different context. Recent approaches by different designers have been addressing this immaterial reality, developing work around subjects like information, data, internet, surveillance, privacy, identity, copy-right, etc.

Critical design has been committed to abandon the commercial context of the practice, but ignoring a critical stance towards the artistic context on which it has been mainly disseminated, as the commercial and labour aspects of critical design are usually left aside, it runs the risk of being incorporated by this context, and eventually loose its significance as a critical approach.

> "It is not so strange that a branch of graphic design has evolved that no longer hangs around waiting for an assignment, but instead takes action on its own accord. It has polarized into the 'willing to work', who often have little or no control over their own positions, and the 'out of work', who, with little economic support beyond re-channelled subsidies or grants, work on innovation for the sake of innovation." (Velden 2006)

Some influential graphic design schools, such as the Royal College of Art (UK), the Yale University School of Art (USA) or the Wekplaats Typographie and Sandberg Institute (Netherlands), have focused their curriculum on the development of critical graphic design, sprouting a new generation of designers willing to step out of the traditional logic of the design marketplace and establish independent working methods.

However, we could argue that it is easier to present a critical stance towards the past, focusing on the working relations of commercial design that are usually portrayed as extremely negative, referring to the lack of autonomy of individual designers within the corporate culture. Understanding the new labour relations characterised by the current push for autonomy and self-expression

could provide more insight on the structural motivations of critical design. Summoned as author, editor, publisher, producer, entrepreneur, programmer, archivist, visual journalist, tool maker, curator, storyteller, pedagogue, artist, researcher, and enabler, the responsibility of designers seems to be on a pedestal. If graphic design is to "offer the surplus value, the uselessness and the authorship of their profession to the world, to politics, to society" (*Ibidem*), it will have to come to terms with two contradicting sides: its social role as dictator of taste, with that of a self-conscious designer who understands the impact of his work.

Considering the academic nature of this thesis, as well as my short professional experience, I will focus on the latter. In fact, the possibility of an experimental context and commercial detachment is seen as an opportunity to search for values on which to ground my future professional practice, more specifically, an editorial practice.

3.2. EDITORIAL DESIGN

Through my education in communication/graphic design, I have come to understand editorial design, not as a practice of designing books, but rather as a practice of design through edition. Given the expertise of graphic designers, books are simply the most common output. However, as contemporary graphic design argues a broader set of capabilities, different supports can be imagined. An exhibition, a film, a catwalk fashion show, a festival or even a political program could be understood as a possible practice of editorial design. The methods of this practice are focused on tasks such as research, analysis, deconstruction, reconstruction, synthesis, assimilation, comparison, categorizing, translating, copying, reusing, etc. Through these, editorial design edits content, and besides defining its possible shape, it defines its meaning.

This conception of editorial design places content in the centre of attention, displacing form into a secondary plane, arguing for a practice towards the relation between designer and content, instead of designer and form.

To better understand this conception, we can lean on the example of the seminal book *Cradle to Cradle: Remaking the Way We Make Things*. Published in 2002 by the chemist Michael Braungart and the architect William McDonough, it followed the progressive discussion around the ideas of sustainability and ecological awareness within the generality of design.

The book suggest a revision of the industrial production process, criticizing the model of reduce-reuse-recycle as a cradle-to-grave system that promoted downcycling, the process of converting waste materials or useless products into new materials or products of lesser quality and reduced functionality. Eventually, these downcycled products would end up as unusable waste, hence, this system would only prolong the effects of industrial activity without necessarily solving the issue of creating a sustainable and ecological production system. The suggested alternative would be a cradle-to-cradle system, where materials could be reused in a process of upcycling, either they could re-enter

the environment in the case of biological materials, or they could remain in the closed loop of industrial production in the case of technical materials.

The amazing characteristic of this book is that it was produced with entirely reusable materials, in accordance to the production model that it proposed. Pages are made of durable synthetics created from plastic resins and inorganic fillers that can be recycled over and over without loss of quality. Ink is non toxic and can be washed off with a safe chemical process or an extremely hot water bath. It is truly a remarkable achievement, but somehow, after more than a decade, and despite the increasingly social awareness of graphic designers, books are still made out of wood…

After a presentation of the book in 2003 during the AIGA's *Power of Design* conference in Vancouver, Michael Bierut would write: "Here, at last, was true certainty: the promise that every piece of graphic design, each an amalgam of dozens of arbitrary, intuitive, 'gee, this looks right to me' decisions, could be put into a centrifuge, broken down into its constituent parts, and analysed for the harm it could do to our environment." (Bierut 2003)

Michael Bierut misunderstood the book as a new purpose for graphic designers, a purpose that could replace the Modernist universal utopia, trying to underpin sustainability as a mission for graphic designers. Instead of improving "the life of every person on earth beyond measure by exposing him or her to Helvetica on a three-column grid" (*Ibidem*), graphic designers could now focus on a new function by considering the environmental consequences of their profession, acquiring once again the comfortable functional role where "you didn't have to have an authorial point of view, political conviction, or even be particularly talented."

However, the material objectivity of its message and the pertinent physicality of its proposal, suggests an approach to design that despite being valid, it is irrelevant. *Cradle-to-Cradle* can only be understood as an important contribution in the context of industrial design as its underlying values are of no consequence for communication design.

Even so, it is understandable to regard sustainability and ecology as fundamental values for the development of industrial production, considering the environmental consequences of such a practice. Certainly it would help if all the posters, flyers, leaflets, banners, stickers, books and whatnot, were produced in such a way. Be that as it may, it is a matter of production, not of communication. The problems of design, given its immaterial nature, suggests a different set of values to guide its practice, values that will be substantially different than those of the material past, both in its characteristics and its implications.

Having said that, it seems important to search for these values, distancing a practice of editorial design from the constrains established by our Modern heritage. It is in this sense, that I called this thesis as an approach towards an autonomous editorial design. Autonomous from its materialistic function, autonomous from the limitations of a polarised practice, autonomous from form.

4.
VALUES FOR COMMUNICATION

4.1. SPIRIT

Anecdote of Men by the Thousand

The soul, he said, is composed
Of the external world.

There are men of the East, he said,
Who are the East.
There are men of a province
Who are that province.
There are men of a valley
Who are that valley.

There are men whose words
Are as natural sounds
Of their places
As the cackle of toucans
In the place of toucans.

The mandoline is the instrument
Of a place.

Are there mandolines of western mountains?
Are there mondolines of northern moonlight?

The dress of a woman of Lhassa,
In its place,
Is an invisible element of that place
Made visible.

Wallace Stevens

4.1.1. ZEITGEIST – TIME

"Graphic design is (...) written about and documented largely in terms of its representation of the zeitgeist." (Erlhoff 2008, p. 199) Dating from mid 19th century from the German *Zeit* (time) + *Geist* (spirit) (Oxford Dictionary of English), its origins in time are close to those usually attributed to Graphic Design and according to wikipedia, the term is usually attributed to the philosopher Friedrich Hegel, and despite he never used it in such a contraction, it is clear that the term appeared during this period.

Zeitgeist can be said to be the crystallized *milieu*, the grand narrative or even metanarrative, the cultural global mean, the epoch. History tends to narrate the past as a succession or as a gradient of such things. First the physical, from stone to metal (bronze and iron), then the spirit, ranging from orthodox to protestant, from the dark ages to the enlightenment, from classical to futuristic. As things become faster, the subdivisions increase with progressively more *spirits*, until modernity. After that, a new *spirit* is a post spirit, as if there wasn't time enough for a renewal. Suddenly, *"post-modernism* is dead" (Kirby 2006) and new *spirits* are born: *post-postmodernism, pseudomodernism, digimodernism,* or the latest *metamodernism*. So fast it is that it seems to consist more of an implosion rather then a continuation. On the 2010 article *Notes on metamodernism*, Timotheus Vermeulen and Robin van den Akker argued for a new *zeitgeist* "oscillating between a modern enthusiasm and a postmodern irony" (Vermeulen & Akker 2010), suggesting that post-modernism is not entirely overcome, but rather it is deepened. However, this may be the result of an increasing capacity to record history shifting towards a record of the future instead of a record of the past.

The idea of *zeitgeist* is strongly related to Hegelian historicism, defining a conception of history based on dialectical thinking, where the negation of circumstances can be seen as the driving force of history. In this conception, "the 'spirit of the times' does not indicate a homogeneous state of affairs in which everyone goes along with the same idea, but rather expresses the fact that in any given society, there is a certain 'language', culture or range of concepts in

which every dispute, every contradiction must be fought out. This 'political terrain' which is expressed in the Zeitgeist operates 'behind the backs' of the participants, it is the unspoken agreement which underlies every dispute." (Marxist Internet Archive) This suggests that history can be read as the evolution of the *zeitgeist*, arguing for a social construction where social interests and the development of the productive forces underlie and condition political conflict and cultural production. Hegel would therefore be fundamental to the development of marxist historical materialism.

Karl Popper would be an avid critique of this form of historicism dismissing it as the grounding arguments for authoritarian and totalitarian regimes by removing the democratic responsibilities of each individual. If we understand *zeitgeist* as a fixed set of ideals and values, it is understandable that it could be used as a moral interpretation of history, advocating the idea of a determined objective and the idea of progress that goes with it. He would therefore reject Marxist historicism accusing it of an economical historicism leading to a valorisation of equality over freedom. (Popper 1945) Popper would become a proclaimer of liberalism, instead of socialism, arguing for a critical analysis of a step-by-step social construction, instead of an ideologically grounded political system. Despite his critics towards Hegel and Marx being often dismissed as unfair and based on misinterpretations of their writings, Popper would mark an important critical stance over a neutral interpretation of *zeitgeist*.

In 1979, Jean-François Lyotard argued that as "societies enter what is known as the postindustrial age and cultures enter what is known as the postmodern age", "the proliferation of information-processing machines" (Lyotard 1984, pp. 3-4), was changing the "nature of knowledge", defining "*postmodern as* incredulity toward metanarratives" such us "the dialectics of Spirit, the hermeneutics of meaning, the emancipation of the rational or working subject, or the creation of wealth" (*idem*, p. xxiv). This gradual fading of grand narratives would give place to micro narratives relating to smaller, local and different realities overcoming the search for an universal truth.

If *zeitgeist* was difficult to determine, it becomes even harder, predicting a certain strain in abandoning the comfort of Modernism, specially for design, a practice deeply rooted in functionalism (Burkhardt 1988, pp. 145-151). The difficulties of Michael Bierut in abandoning the "certainties" of the Helvetica crusade while working for Massimo Vignelli, or Paula Scher's defence for a neutral practice, reminds us that "the illusions of rationalism die hard." (*Ibidem*)

In the light of *zeitgeist*, we can relate the gradual withdrawal from *modernism* with the more recent transformations of design practice. If design truly represents the *zeitgeist*, then we must conclude that changes in the *zeitgeist* will result in changes in the representation. The evolution of the most elementary components of visual communication, the typeface, indicates how direct this relation can be reckoned. During the early *modernism* "the form of the faces reflected the greater technical sophistication of eighteenth-century punch cutters. (...) Modern types emphasized the intellectual ideals in forms that marked their distance from the physical act of handwriting. Body and mind were distinguished, the trace of the hand was banished, and rationality prevailed over gestures and feelings. Humanistic models based in manuscript brush and pen strokes were displaced by a calculated approach to measure and proportion. Even handwriting was subject to new rational discipline." (Drucker & McVarish 2009, p. 108)

Nevertheless, this initial idea of "representation of the *zeitgeist*" stands for a rather neutral position, where all that designers can do is represent, without any capacity to contribute to the change that *zeitgeist* might contemplate.

In the 1958 essay *Man in the Middle*, Charles Wright Mills puts forward the idea of "cultural apparatus" as the sum of "all those organizations and milieux in which artistic, intellectual and scientific work goes on" and "all the means by which such work is made available to small circles, wider publics, and to great masses. (...) it conquers nature and remakes the environment; it defines the changing nature of man, and grasps the drift of world affairs; it revivifies old aspirations and shapes new ones. It creates models of character and styles of feeling, nuances of mood and vocabularies of motive. It serves decision-makers,

revealing and obscuring the consequences of their decisions. It turns power into authority and debunks authority as mere coercion. It modifies the work men do and provides the tools with which they do it; it fills up their leisure, with nonsense and with pleasure. It changes the nature of war; it amuses and persuades and manipulates; it orders and forbids; it frightens and reassures; it makes men weep and it makes men laugh, go numb all over, then become altogether alive. It prolongs the life-span and provides the violent means to end it suddenly. It predicts what is going to happen and it explains what has occurred; it helps to shape and to pace any epoch, and without it there would be no consciousness of any epoch." (Mills 1958, p. 174)

By naming it as an apparatus, he portrays a different image of zeitgeist, one that does not simply appear out of the bloom, but instead as a result of the interplay between "communications and designs, patterns and values"82 where designers are the "men in the middle" between "human consciousness and material existence". Even if his conclusions hover mainly on industrial/product design and architecture (mainly material and physical practices), we can take interest on the recognition of a significant role of designers for reshaping the *zeitgeist*:

> "As members of this cultural apparatus, it is important that designers realize fully what their membership means. It means, in brief, that you represent the sensibilities of man as a maker of material objects, of man as a creature related to nature itself and to changing it by a humanly considered plan. The designer is a creator and a critic of the physical frame of private and public life. He represents man as a maker of his own milieu. He stands for the kind of sensibility which enables men to contrive a world of objects before which they stand delighted and which they are delighted to use. The designer is part of the unity of art, science and learning." (*idem*, p. 181)

Historically, we can glance at the work of the avant-garde movements to understand how design can conceive representations that defy a passive and neutral position. The book *Merz to Emigre and Beyond: Avant-Garde Magazine Design of the Twentieth Century* (2003), by Steven Heller, presents a thorough history of publications whose whole purpose is to "destroy all existing value

systems" (p.9). Most notably, we can point to the publications developed during the Futurist movement. The arguable relations with the Italian Fascist party would bring the vanguard, led by Filippo Marinetti, into all spheres of society, from periodicals, to political and war propaganda, advertisement, and most famously, into art. Despite consisting of a "revolutionary paradigm" with deep influences in the progression of modern art, "its underlying ideology remains unsavoury" (*Ibidem*). Nevertheless, "Italian Futurism was the perfect vehicle for a moment that advanced cultural renewal through technology and social purification through war" (*idem*, p. 34). Its political backbone allowed it to trail its path without much resistance confronting the idea of a conservative representation of the *zeitgeist*.

An earlier example given by Heller, the German magazine *Simplicissimus* that focused mainly on political satire, was not free from friction. Unlike the Futurist publications, these were not running parallel to a political vanguard. "The authorities instituted stern measures to muzzle the dog [the character that personified the magazine], but despite attempts at censorship and frequent arrests for blasphemy against the royal court, the illustrated tabloid rarely missed a scheduled appearance. When it was confiscated by the police, a black, red and white poster, designed in 1897 by Thomas Theodor Heine, on which the dog was poised, warned friend and foe alike that *Der Simpl* could not be chained up for long. In fact, while bans lasted only a week or two at the most, rows of these posters hung for months at a time and undoubtedly attracted new readers to the magazine." (*idem*, p. 21) Eventually, between the First and the Second World War, the magazine would loose its focus replacing its critical stance towards internal issues for a tool of political propaganda, scorning the enemy and becoming the "lapdog" (*idem*, p. 22) of Nazis. This fact may be a strong indicator of the capacity that *Simplicissimus* had to disrupt the leading *zeitgeist*.

The relation between *zeitgeist* and graphic design is clear. As a spirit, we can represent it and suggest different views of it, but it is entangled with time in such a way that presupposes a generalist and universalistic approach. Time is another social construction such as that of spirit and it ignores different

subjectivities such as geography, weather, language, etc. The prior examples of the Futurists and Simplicissimus, can't be explained only through the optics of time, but rather through the place and condition over which they occurred. Within an age of pluralism, with no singular narratives, the idea of *zeitgeist* as the spirit of the time is a limited analysis. To expand it, we need to look further and closer to reality.

I am possibly approaching an analysis of design through marxist materialism but I would like to keep a conscious distance from it. Notwithstanding the pertinence of current social and productive relations of design, I would consider this in a later moment, after exploring the ideas that those eventual relations might reflect. The productive relations themselves, are the main thesis of this essay, by trying to suggest a practice of editorial design through this document in itself.

4.1.2 GENIUS LOCI – SPACE

Looking deeper for an expanded idea of *zeitgeist*, one that might go beyond the characteristics defined by time, I came across the notion of *genius loci* that could provide the ground to define an idea of *spirit* characterised by its local context.

In the 1980 book *Genius Loci: Towards a Phenomenology of Architecture*, Norbert-Schulz, introduces phenomenology theories into architecture developing the notion of 'spirit' within architecture based on the 'phenomenology of place". Despite my hesitations about looking to architecture for references, it can sometimes prove useful.

Schulz finds that the "environment influences human beings, and this implies that the purpose of architecture transcends the definition given by early functionalism" (Norberg-Schulz 10980, p. 5), concluding that there are other elements such as "meanings", "symbols" and "perception", that have influence defining the 'spirit of a place', the 'Genius Loci'. Borrowing from the works of philosopher Martin Heidegger he points out that "man dwells when he can orient himself within and identify himself with an environment, or, in short, when he experiences the environment as meaningful", defining architecture as the "concretization of existential space", and further developing the concept of "existential place" as the relation between "space" and "character", in other words, the relation between nature and men.

> "The man made environment where he lives is not a mere practical tool or the result of arbitrary happenings, it has structure and embodies meanings. These meanings and structures are reflections of man's understanding of the natural environment and his existential situation in general." (*idem*, p. 50)

Schulz brings us to an "existential dimension" where meanings have their origin in the structure of our "being-in-the-world" and not from socio-economic relations, which work only as borders that help or restrain development, however, it is not from these relations that existential meanings emerge.

4. VALUES FOR COMMUNICATION
4.1. SPIRIT

In the light of Schulz's ideas, developed during the 60s/80s, the historical moment of extreme organizational and productive complexity, at a global scale never seen before, presented a difficult reality for the creation of pertinent meanings, as they were no longer connected to the physicality of places. He defines a *loss of place* as a reality where there no longer exists a symbolic relation of spaces between the *being-in-the-world* and people.

Despite the good intentions of the early modernists to bring back a meaningful way of life, the plan ends up failing, specially within urban contexts. Schulz considers two reasons for this: the latter misinterpretation of modern pioneers such as Frank Lloyd Wright and Le Corbusier within the urban context — as the city demanded for a solution for the private/public space that wasn't solved through the "blown up" house —, and the emergence of the International Style, responsible for what Venturi would call "architecture of exclusion". The alternative, embodied by architects such as Alvar Alto, would be a New Regionalism, trying to "give buildings and places individuality, with regard to space and character". However, 15 years into the new millennium, this refreshed take on modernism is still pretty much unaccomplished.

Towards the end of the book, Schulz ends up reviewing the modern discourse by expanding its functional role within regionalism, but accepting a neutral position for architecture. By concluding that "this direction is not dictated by politics or science, but is existentially rooted in our everyday lifeworld" (*idem*, p. 201), he fails to understand the implications of his own initial claims that "meanings and structures are reflections of man's understanding of the natural environment and his existential situation in general".

He seems to ignore the complexity of contemporary human condition and its relation to the environment, or at least he simplifies it, as science and politics are indeed "existentially rooted in our everyday lifeworld". I will be further exploring this issue but firstly, we can question his conception of *being-in-the-world* as a straightforward relation between men and a "natural" environment.

> "By his distribution through all climatic regions and his power to employ great physical forces, man has become the guide fossil of the present geologic period. A consciousness of this geologic role of man is necessary for the continued well-being of future generations." (Sauer 1916, p. 104)

If human action changes the environment itself, then we must conclude that the relations between men and space must also change. The idea of *loss of place* might just be too simple to define the results of contemporary reality. The law of conservation of mass states that nothing is lost, everything is transformed and I find it difficult to admit that symbolic relations between the *being-in-the-world* and people simply ceased to exist, creating a *loss of place*. I would rather admit that with the advent of modernity, the *being-in-the-world* has changed dramatically, drifting far from a direct relation with the "natural landscape". An inversion of the expression, *place of loss*, is probably more adequate to define the reality of the late 20th century. For a few years now, more than half of the world population has shifted towards urban areas. But for developed regions such as Europe and North America, this reality has existed for far longer, with 73% of the population currently living in urban areas within Europe and 80% in North America. Globally, the tendency is increasing, mainly due to urban developments in Asia and Africa (United Nations, Department of Economic and Social Affairs, Population Division 2014).

If we consider that our current *being-in-the-world* is mainly dominated by urban contexts, or by a socio-economic reality, what are the emerging meanings that designers are supposedly representing? Besides, if we acknowledge the grounds of contemporary design within modernism, we must therefore recognize the idea of *loss of place*, or its inversion, the *place of loss*, as the main framework of design, be it architecture, industrial or communication.

4.2. THE MAN-MADE SPIRIT

4.2.1 BINGS

In 2011 I was in Vimy, in the region Nord-Pas-de-Calais, the further north region of France, visiting a memorial to the I World War in a high place of the geography. From there, I could see about five dark mountains, maybe 10 kilometres away, all of them with more than 100 meters. In the Flemish flatland this mountains stood out quite prominently. The sight was mesmerizing and I didn't understand what they were. The images of the Egyptian pyramids were flashing in my memory, suggesting an evident human intervention. But the cones were circular and irregular, without side faces, presenting picturesque and *naif* images of mountains of a characteristic shade, giving the impression of sublime creations of Nature.

It was only later, when I eventually asked the local that was accompanying me, that I realized it was indeed something artificial, made by men. In French, they are called *terrils*, in English they are known as spoil tips, or bings – man made heaps of leftovers and residual rocks from mining exploration that, after being separated from the coal, are stacked in the surface of the mine. I was looking at the mining area of Nord-Pas-de-Callais where there are over 300 *terrils*. Of those *terrils*, 51 are defined as world heritage by Unesco.

Coal is the byproduct of the decomposition of vegetative mater without the presence of air. It is a very long process: in a sweet water shallow lake, a forest establishes; the bottom of the lake sinks (phenomenon of subsidence), the flooded vegetation dies and it later transforms into coal; when the subsidence slows down, the lake slowly refills again; when the water depth allows it, the forest grows again and restarts a cycle that usually lasts around 50 thousand years; dramatic climate changes eventually stop the cycle as the lakes won't refill and the forest won't regrow; the mineral then awaits for someone to dig it out.

In 1720 the first coal in the north of France is found in Fresnes-sur-Escaut, marking the beginning of coal mining in the north of France. In the region of Liege et Mons, in Belgium, coal was literally at the surface, or at very low depths and mining starts during the XII century, 500 years before the north of France. Belgium also has it own *terrils*. Actually, they can be found all over the world wherever there are mining operations. The north of France however, presents an ideal place to observe this human phenomenon due to its flat topography and to its history that allowed these hills to remain. In the USA for instance, mining companies were forbidden to abandon the leftovers after the operation had ceased.

There are different kinds of *terrils*. The flat ones are the oldest. At the time, the wagons full of rocks were pulled by horses or men, so the slope couldn't be very steep. Also, they didn't have to make them extremely high as there was enough space to spread around. Eventually, urbanization came to limit the expansion of these mounds. Technological innovation placed the wagons in a mechanical harness system allowing for the remains to be dropped at considerable hight occupying less space and demanding less labour.

Working in the mines has never been easy, but previously to the XX century, working conditions, specially those of miners, were infernal. They worked 6 days a week and depending on the company, 10 to 15 hours a day, with no paid vacations, no social security, no sanitation, exposed to all kinds of diseases, at temperatures that could vary from 20° (at 350 meters deep) to nearly 50° (at 1150 meters) and all this in a dusty environment. Accidents were frequent (gas explosions, mud slides, floods, etc.), resulting in dozens or even hundreds of deaths. Most of the work was paid in advance and security, for greed, was neglected by the workers themselves.

Today *terrils* are considered as heritage worthy of preservation, with their own weekend excursions, hunting seasons, complex fauna and flora, even spontaneous combustions due to the concentration of coal.

At this point, I should probably apologise for the long description, but all

this was necessary for the purpose of confirming Nature's amazing dexterity for making mountains. It is the "unprogrammed" result of the "programmed" exploration of geological resources by man.

Given their scale and contrast with the French northern landscape, they present a monumental character, and despite being artificial, they assume an in-between condition, as something in the edge or in transformation, from human control to nature's chaos, into a position that contradicts the presupposed idea that what is artificial, is not natural.

Terrils are therefore an useful argument for discussing the problems raised by the idea of *genius loci*, mainly, the *loss of place* as a reality where there no longer exists a symbolic relation of spaces between the *being-in-the-world* and people. This idea was based on the fact that the *being-in-the-world* was essentially related to natural environmental context and this was the point of origin for the creation of pertinent meanings and consequent representations. However, as the *terrils* come to show us, the only relation that ceases to exist is with a preconceived notion of "natural world", as pertinent relations with the existing elements keep on being created, even if reality as we know it is quite different from what we use to call "natural world". If design truly corresponds to the idea of representation of the *zeitgeist*, then we need to understand our current "spirit" beyond any preconceived notions of our *being-in-the-world*.

4.2.2 ARTIFICIAL AS NATURAL

The dichotomies human/animal, culture/nature or artificial/natural, all revolve around the same issue and have been a frequent case of inquiry throughout history, but we can acknowledge that recent technological advances together with the expansion of civilisation and its environmental issues have made the discussion progressively more complex.

The earlier Greek philosophers had it easy. The relatively straightforward relations of men and their surroundings allowed for a very pragmatic perspective. *Physis* and *techne*, the ancestors of 'nature' and 'artificial' derive from a relation of contradiction: through art, man could conceive of ways to contradict the imposed tendencies of nature. Further knowledge and capacity, lead medieval interpretations to perpetuate this conception by thinking of artificial as falsification and mechanical trickery. In the seventeenth century, Descartes would reject this notion claiming that, if we could see very close, nature would reveal itself as mechanical. In the eighteenth century Jean-Jacques Rousseau would state that nature was an intellectual construction, "an indispensable fiction for ascertaining the foundations of the political order" (Bensaude-Vincent & Newman 2007, p. 2). The dichotomy was kept alive within common sense, and the contemporary construct is certainly a descendant of this tradition.

However, one question seems clear enough. "Why should the products of one particular natural species be seen as somehow escaping nature?" (Vogel 2003, p. 149) The contradiction appears to be obvious. If Human as a species is a product of nature, then doesn't all that it creates fall within the same domain?

Nature can be defined as the entirety of all physical mater. All the plants, the animals, the rocks, the mountains, the rivers, the oceans, the clouds and the plants. The elements define nature. But events do as well, as relations between elements. A storm, rain, a volcanic eruption, a wave, gravity, cold and heat, fire and wind. No one will doubt that these are part of nature. Humans however, are usually defined as something else entirely separate from nature. Their production, culture, art or the artificial, are also not natural. It may

copy natural things but they do not occur naturally, as they are made by man, and apparently, man is not natural. Artificial is thought of as fake, not true, not real, not existent in nature. On a more dramatic tone, it can be seen as anti-natural, as violating nature.

Clearly this doesn't make much sense, and if by any means this conception ought to stand, then we should conclude there is no nature left. Humans took over it. (McKibben 1989) Without industrial gas emissions, temperatures around the globe would be different, without boats the oceans would be more silent, and without cities the night sky would be darker. "Over centuries and millennia of agricultural and industrial activities nature has been deeply reconfigured by humans. 'Native forest' in the sense of woodland absolutely untouched by humans exists nowhere but in the human imagination. No part of the earth has been completely unaffected by the effects of human technologies." (Bensaude-Vincent & Newman 2007, p. 2)

Also, if the products of human creation are not natural, then why should they have any impact on nature? And why should some human actions, such as reproduction, sleeping or eating be labelled as natural, and instead, others like reading, writing or cooking as cultural?

Seth Lloyd, professor of mechanical engineering at MIT, suggests that the universe itself functions much like a quantum computer, stating that with an eventual theory of quantum gravity, a quantum computer could simulate the universe in its entirety. (Seth 2006)

> "Chemistry has this computational nature embedded in it, which it inherited from the underlying computation that's going on in quantum mechanics in general. (…) Chemistry explores all possible computations, all possible things that could happen — including all other things that a computer can do. (Seth 2008, pp. 148-149)

Despite difficult to imagine or accept, it places human existence and all its production in the same plane as all the other existing things, taking Descartes proposition even further, suggesting that not only is nature intrinsically mechanical, it is computational.

The notion that artificial artefacts belong to the natural environment seems to be clear. Nevertheless, and before addressing the implications of this conclusion, I must consider one different utility for this dichotomy. "The concept of nature functions and has always been used as a cultural value, a social norm, and a moral authority" and hence "we cannot simply dismiss the distinction between art and nature as a 'popular prejudice' or as an 'irrational nostalgia for the past'". (Bensaude-Vincent & Newman 2007, p. 3). In fact, the same "rational" and materialistic arguments that I have been presenting have already been used to "normalise" the advances of industrialisation, approaching Rousseau's intellectual construction of nature as "an indispensable fiction for ascertaining the foundations of the political order". In fact, contemporary voices against the advances of technology tend to focus on the negative influences that they produce within the natural environment, as well as the nefarious consequences on social well being. This stance has deep roots in the belief of a world where nature is essentially seen as balanced, harmonious, positive and fertile, as opposed to technology. We might name different origins such as old pagan traditions, religions or even anthropocentric narratives such as humanism, but essentially we should emphasise it as a cultural conception that doesn't necessarily correspond to the physical reality. Due to the cultural value of nature, we tend to use it as a process of normalisation. If something seems to be natural, it is therefore normal that it occurs. We can tolerate it and allow it. If it is anti-natural or unnatural it stands to reason that it must be abnormal, it is not supposed to be like that and it should be contradicted.

Being a recent issue in the media, gay marriage is a good example. We can see in the United States, and in other countries as well, how religious groups tend to deny the rights of homosexuals based on a normalising view of nature, as God intended it to be. Non religious people can also argue for the same positions naming it as unnatural since it contradicts the natural notions of reproduction,

parenting or family. Nevertheless, on 26 June 2015, USA supreme court ruled in favour of homosexuals making same-sex marriage a right nationwide. The first country to legalise same-sex marriage was the Netherlands in 2001, and since then other countries have followed, demonstrating an abandonment of rules based on their naturalness in favour of social constructed acceptance. Be that as it may, it is a very recent trend applied to a social struggle that has been going for many years, and the moral value of nature is still strongly present of many grounds.

By suggesting that all artificial artefacts are part of nature, I run the risk of admitting a normalisation of all human contemporary artificial relations in the moral sense of the word. The relation between humans and other animals, the relation between the environment and human production, the relation between workers and their production are some of the most pertinent matters that come to mind that cannot be easily dismissed. However, seeing this relations as natural is one thing, but admitting that they are normal is something entirely different. To understand this we need to dig deeper in this conception of nature.

4.3. NATURAL CULTURE

4.3.1. EVOLUTION

The theory of evolution is central to our discussion. It is the explanation of our direct relation to the environment and we can see human production through this prism. Contemporary biology still heavily relies on the notions laid out by Charles Darwin in 1859, even if the knowledge regarding natural selection has been deeply expanded. However, it only considers two main stages of evolution: first, around four billion years ago, with the appearance of self-replicating unicellular organisms and then, after three billion years of monopoly of these simple life forms (around one billion years ago), the formation of multicellular organisms. Humans descend from this multicellular evolution, and the story ends there, or so it seems. That is the story of genetic evolution. However, the complexity of the human episode would compel the story further.

The first two stages of evolution focus on hard-wired mechanisms, features of adaptation that are innate and tend to be passed on to the offspring through genetic transmission. The changes in genetic code are relatively slow as they happen by mere chance, through cumulative errors, during the process of copying. The advent of sex for reproduction helped to accelerate the process of change as it allowed natural selection to create more diversity concerning different adaptation necessities. If only the healthy, the strong, or the cleaver, or tall, small, or whatever the characteristic that made a particular individual successful in reproducing itself, then, its genetic code is going to be copied, along with the characteristic that made it successful. The complexity of the natural environment would allow for a wide variety of lifeforms adapted the different exploitable circumstances.

Evolution is something that just happens, without an existing intention. Actually, an effort is made by genes to avoid evolution itself, as the process of reproduction is an attempt to make a perfect copy. Evolution however, relies on the accidental but fruitful errors. From our point of view, as Humans standing at

the tip of this evolutionary process, we enjoy the idea that evolution leads to us, to consciousness, to culture. Not only that, but our time perception is simply an obstacle to understand evolution as an accumulation of errors happening throughout billions of years. The animation of a small bacteria that progressively transforms into a fish, and then a toad, and then a lizard, then a mammal, then a ape and then a human, misguides our conceptions. It leaves out many other lifeforms that have evolved into different branches. Also, it leaves out the millions that die between each frame. The theory of evolution is often read as the history of humans leading us to treacherous interpretations. This misconception will eventually conceive a sort of social-darwinism, applying the idea of survival of the fittest within society and politics. One might think that certain cultures are more advanced than others, more adapted or more fit. Thoughts like this were common during the Second World-War. Nazi ideology was quite keen on it, defending a superior race and justifying eugenics, racism and imperialism. This kind of conclusions must be avoided, and for that, we must understand evolution as a neutral process. Genetic evolution happens only because it can, not because it should. This is the common misconception that allows for "natural" to be confused with "normal". Nature is neutral, it is our interpretation of it that dictates normalising moral values.

Having said that, we can better understand the important role of the theory of evolution for our conception of nature. The interpretation we make of it determines the position and relations of humans with the preexisting environment. Darwin himself avoided talking about the evolution of human beings as he knew that it would bring him difficulties regarding religious prejudices. Even the title of his book avoided the term "evolution", opting to choose "On the Origin of Species by Means of Natural Selection" as a safer option. Also, he acknowledged many unanswered questions that would widen the field of natural history. In the last and concluding chapter of his book he writes: "In the distant future I see open fields for far more important researches. Psychology will be based on a new foundation, that of the necessary acquirement of each mental power and capacity by gradation. Light will be thrown on the origin of man and his history." (Darwin 1859)

As hominids developed a hard-wired plasticity, the innate capacity for learning, and consequently language, the history of evolution takes a new course into what we know as culture, giving way to the third evolutionary step – cultural evolution. It is within this interpretation that the work of communication designers might become pertinently justified.

The main ideas that would substantiate this notion of evolution were developed by Richard Dawkin's in his 1976 seminal book *The Selfish Gene*. Throughout the book he argues for the gene as the single unit of interest, the unit that tries to preserve itself through replication. Cells are the vehicles for genes, and the different species are "survival machines", composed by the cooperation of multicellular organisms that allow genes to thrive. Parallel to this idea of genetic transmission, he suggests the rise of cultural transmission where besides the gene, a new replicator would emerge, the "meme": "a unit of cultural transmission, or a unit of *imitation*. 'Mimeme' comes from a suitable Greek root, but I want a monosyllable that sounds a bit like 'gene'. I hope my classicist friends will forgive me if I abbreviate mimeme to *meme*. If it is any consolation, it could alternatively be thought of as being related to 'memory', or to the French word *meme*. It should be pronounced to rhyme with 'cream'. (…) Examples of memes are tunes, ideas, catch-phrases, clothes fashions, ways of making pots or of building arches." (Dawkin 1976, p. 192)

Interestingly, evolution does not necessarily need organic life for it to happen. "The outlines of the theory of evolution by natural selection are clear: evolution occurs whenever the following conditions exist: (1) variation: a continuing abundance of different elements (2) heredity or replication: the elements have the capacity to create copies or replicas of themselves (3) differential 'fitness': the number of copies of an element that are created in a given time varies, depending on interactions between the features of that element (whatever it is that makes it different from other elements) and features of the environment in which it persists". (*idem*, p. 200) This is a strictly programmed and abstract conception of evolution substantiating Seth Lloyd's view of the Universe as being intrinsically computational.

Memes can therefore be seen as complex ideas capable of changing throughout time, in a process quite similar to that of genetic evolution. The success of memes depends on the same features that genes do, but inhabiting the different environment of human brains, their relation to such features is quite different. Longevity refers to the lifespan of the element, a relatively unimportant aspect both for genes and memes, fecundity indicates the capacity of the element to make copies of itself, and copying-fidelity relates to its capacity to withstand change during the process of replication. It is easy to imagine the advantages that memes have over genes. Dawkins gives a great example:

> "A meme that made its bodies run over cliffs would have a fate like that of a gene for making bodies run over cliffs. It would tend to be eliminated from the meme-pool… But this does not mean that the ultimate criterion for success in meme selection is gene survival… Obviously a meme that causes individuals bearing it to kill themselves has a grave disadvantage, but not necessarily a fatal one… a suicidal meme can spread, as when a dramatic and well-publicized martyrdom inspires others to die for a deeply loved cause, and this in turn inspires others to die, and so on." (Dawkins 1982)

A car is an artificial physical object consisting of different materials, such as metal, rubber, plastic, fabric and glass, assembled in a specific manner. However, it is also the manifestation of a meme, the idea of a personal means of transportation that exists within human brains. Without humans, the car would exist only as the physical object, and its function as a vehicle would be entirely lost. It is this fragile idea, the part that is lost, that seems to be particularly interesting to graphic designers.

Memes depend on language, written or spoken, to be transmitted. An image, as visual language, can be a tool of transmission as well. The car itself, as a three-dimensional image, can also function as a manifestation of the meme. We can write down the function that we give to the physical object that we call a car, we can explain it to someone, or we can draw a picture of a family traveling inside the car. All considered, it seems obvious that designers might have a significant role in determining the fecundity of a specific meme. Cer-

tainly they are not the only influence, but as "men in between" and "members of the cultural apparatus" (Mills 1958, p. 173), we are now capable of drawing a comprehensive idea of designers as the representation of "man as a maker of his own milieu" (*ibidem*).

C. Wright Mills cleverly points out to the importance of designers acknowledging their role within the "cultural apparatus". If nature is to be neutral, and it is our interpretation of it that dictates the normalising moral values, then, interpreting nature from the third stage perspective (cultural evolution) determines that the moral values are memes themselves, subject to the same artificial constructions as other memes. Therefore, while admitting that culture is natural, I can dismiss the risk of normalising all human creations, not as "popular prejudice" or as an "irrational nostalgia for the past", but rather as misinterpretation. Without this third point of view, the interpretation of nature is limited. Moral values might seem intrinsic, coming from within, hard-wired, even genetic. If instead we conceive the moral values based on the interpretation of nature from a perspective of cultural evolution, we might see them as memes, capable of change through the actions of transmission, as making the drawing slightly different turns the meme into something else.

4.3.2. DESIGNING MEMES

As I started to study Communication Design, I thought it as difficult to see, measure, or understand, the impact that Graphic Design had on our lives, be it in the everyday decision making process or even in the grand scheme of things, but I was sure that there was some sort of impact. Even if little, there had to be some effect. Clearly, it would be difficult to assess, as we would need to isolate the different phenomenons taking place at any given moment of each decision and then be able to identify those that emerged through the intervention of specifically intended visual communication. Perhaps such a task could be possible on small scale actions, like buying a bottle of wine, but for larger events, those that depend on multiple individuals, the mathematical problem would be exponentially more difficult.

Evidently, these questions have already been worked by many and those with the right answers usually work as marketeers, experts who seem to know exactly the way to convey a message for maximum output. Through fields like focus group inquiries, market and statistical analyses, market segmentation, consumer behaviour, and many others, marketing knows all too well the consequences of graphic design. Furthermore, current internet based communication technologies allow for a greater exploration of this knowledge and hinder any conclusive and objective analysis to the influences of graphic design.

These tools have been refined through decades, and today, some consequences of design are not only known, but they are predictable.

Considering the design of labels for wine bottles we might understand the level of consequences I am referring to. Most wine labels are designed according to the price range of the product itself, and its relation to the targeted consumer. If it is a cheap wine, for low income consumers, it will never include a golden embossed script font, a soft paper or a lot of white space. This characteristics would convey the image of an expensive and quality wine and it would miss its target, as those looking for a cheap bottle of wine would quickly dismiss it as a possible option. It would be preferable to have something a bit more

colourful and immediate, without the traces of something exquisite as not to confuse the consumer. If it looks bad it will not be expensive.

This is obviously a generalisation, as people in the trade are always trying to do their best, be it the wine producers, the sales team, or the designers, but somehow in the process things happen this way. There is a strict relation between the price of a wine bottle and the fineness given to its label. Most importantly, it is easy to understand that most of the graphic work is dedicated to the moment of purchase, rather then the moment a product is consumed (consider for instance the white interior of an exuberant package).

We could argue that this is a fair job, as it would be wrong for the Designer to contradict these rules. Ultimately, they would be misleading consumers. If all the products were exquisitely designed, choosing a wine bottle in the supermarket would be even more frustrating then what it already is.

As Daniël van der Velden puts it, design is no longer driven by need, instead, "designers throw themselves into desires." (2006)

This is probably the best answer to our initial questions posed by the idea of *spirit*: if we consider that our current *being-in-the-world* is mainly dominated by a socio-economic reality, what are the emerging meanings that designers are supposedly representing? Furthermore, given the immaterial nature of memes, we can indeed acknowledge the *loss of place*, or its inversion, a *place of loss*, where nothing can be grasped, as the main framework of design.

In the light of the memetic theory (the theory of memes), design within the context of wine labels, like most of the work done by designers, suggests an uncomfortable reality of cooperation within the "cultural apparatus" to communicate essentially the memes of consumerism.

Metahaven, in their book *Can Jokes Bring Down Governments?*, refer to the internet meme – "an image captioned with heavy type, superimposed on it 'for humorous effect'" (Metahaven 2013) – as a field for an active approach

towards political design. "As opposed to 'reasonable debate', jokes are political weapons which deny an opponent control over the terms of the exchange by ignoring those terms entirely. Jokes are a protocol weapon of democracy, unsettling the *structure* of the encounter between oppressor and appressed. Jokes can unsettle the 'terms of service' to which political exchange is bound by its ruling ideology." (*Ibidem*)

The internet meme, due to its dissemination, would receive significantly more attention from graphic designers than its original meaning. The advent of internet social media provided the perfect environment for humorous memes to sprawl, and as a tool, they could indeed provided a method of inducing disruption. However, this conception seems to undermine a more complex understanding of memes as a framework for developing and put in practice the social dimension of graphic design.

Recalling our historical review, what critical design suggests is that with the consciousness of this role within the the "cultural apparatus", designers could use their tools to contradict the dominant *spirit*.

…

5. TOWARDS AN AUTONOMOUS EDITORIAL PRACTICE

Having established the apparent impossibility to clearly define graphic design, I have tried, through this thesis, to develop an example that could be used to substantiate an editorial practice based on values relevant for the specific qualities of graphic design.

Initially I have tried to demonstrate how graphic design has historically shifted from communication towards a form of persuasion. Starting, in the early days of printing, as a work mainly devoted to books, what we now call graphic design was responsible for the advance of the rational ideas leading to the Enlightenment and the subsequent Industrial Revolution. Graphic design continuously expanded its field, covering more specific functions demanded by the emergence of a public sphere and a market of mass-produced products. Progressively, graphic design would be defined as a tool for differentiation, drawing, among other things, brands, identities, newspapers, packagings, and typefaces that served the purpose of standing out in a market of uniform mass-produced objects. Modernism, as a reaction to the excesses of this differentiation process, would argue for a new social dimension of design in the proper integration of industrialisation through clarity, rational organisation, and functional efficiency, fully establishing the practice for the first time. However, by legitimising design, this objective would only serve to perpetuate the problems raised by industrial progress, creating the current state of affairs of graphic design.

The following premises would explore the reactions towards Modernism within the practice of graphic design, more precisely the advent of the First Things First manifesto, marking a clear division within graphic design between persuasion and communication.

Currently, the reactions towards this polarising condition, summarised in the recent specifications of "designer as author" and "critical graphic design", provided the necessary introspection to question not only the social dimension of the profession but also its underlying *raison d'être*. This process of reaction and questioning has led to the realisation that editorial design needs to work outside its traditional role in order to redesign itself as a relevant practice.

Due to the fundamentally different nature of graphic design's content, a fact that only recently became evident, it lacks a discourse capable of sustaining it. Moreover, no only it is recent, it is immaterial, making it relatively more difficult to borrow arguments from the different areas of Design.

As a result, I have tried to look beyond Design's common discourse, searching for a set of values capable of addressing the issues at hand. I have divided these in three groups: *spirit*, man-made *spirit*, and natural culture.

"*Spirit*" confronted the concepts of *zeitgeist* and *genius loci* as a way to understand the representation role of graphic design within any given context. Above all, it puts forward the idea that the representation was a dialectic process and therefore arguing for the impossibility of a neutral practice. Furthermore, it presented the idea of *place of loss* as an inversion of Norberg-Schulz's concept of *loss of place*, suggesting that the symbolic relations between men and their environment had dramatically changed, not disappeared.

"Man-made *spirit*", continued the discussion regarding the symbolic relations between man and its environment. Through a deconstruction of the dichotomous assumption between natural and artificial, I argued for the possibility to see human action within a systemic framework where culture could be understood, not as a separate entity from the natural environment, but instead as a part of it.

The last segment, "Natural Culture", explored the theory of evolution not only to tackle the moral conception of nature as a normalising agent, but also to introduce the notion of memes, mainly through the work of Richard Dawkins, as a possible framework for grounding an editorial practice of graphic design.

With these arguments, I could now discern the impact of graphic design more clearly. Memetics, as a evolutionary theory of mental content, suggests an approach towards graphic design that relates to the processes of its representation rather then the representation itself. Given specific contexts and specific objectives, like in the example of designing wine labels, the practice of design

will transmit specific memes, such as consumerism. We can therefore conclude that graphic design relates essentially to the processes of transmitting specific mental contents. Different approaches towards design will provide different processes capable of transmitting different memes, presupposing a possible path towards a pertinent practice of editorial design. The social dimension of design is manifested mainly through the context on which it takes place. If a designer works for industrial corporations, or cultural institutions, or academic research, or art galleries, or conferences, or television, or theatre, or ONGs, he will be using different processes that define the transmitted memes. Embracing the process, we place formal aspects of design, such us typography, shape, colour, image, dimension, white space, platform, etc., in a secondary plane.

> "Just as John Cage, a musician, had to give up music in order to realise his experiments with composition as process, so designers must dismantle their traditional roles as arbiters of taste and dictators of physical forms in order to participate in the more conceptually oriented understanding of designing as a continuous process." (Mitchell 1988)

The process of this thesis provided the necessary context to achieve such an understanding. However, the context on which design happens, is not always defined by the designer. The dominance of a capitalist driven market, dictates a narrow set of possibilities.

The Netherlands for example, a country much praised for its design, provided large state support to the arts, allowing for broader contexts on which to establish different practices of design. As Peter Bil'ak denotes, "the existence of young, small studios in the Netherlands is made possible though financial grants from various cultural funds. The BKVB (The Netherlands Foundation for Visual Arts, Design and Architecture), for example, subsidised more than 5000 artists and designers in recent years, enabling them to concentrate on developing their work, to keep afloat in day-to-day practice or finance their personal projects. Such support offers newly-starting designers an opportunity to establish themselves without major financial difficulties." (Bil'ak 2004)

Studios like Metahaven, Lust or Experimental Jestset, have benefited extensively from this setting, creating their own niche through an autonomous practice that preceded their involvement with the preoccupation of achieving sustainability though their practice.

The work of Stuart Bailey, one of the first participants at the post graduation program of Werkplaats Typografie, is also worth mentioning, mainly due to its contributions to the independent editorial design scene, through the publication of the Dot Dot Dot magazine and the proceeding project, The Serving Library. He admits that "one of the reasons for staying in Amsterdam was definitely that glut of famous arts funding which allowed me to work on more interesting and self-generated projects like Dot Dot Dot". (Sueda & Bailey 2006)

More recently, the tendency for austerity measures within Europe led to significant cuts to the financial support of the arts, and the Netherlands was no exception. Within my particular Portuguese context, the possibility to achieve some kind of autonomy is considerably more difficult. However, the challenge is now clear: for graphic design to fulfil its social role in accordance to its own values, it needs to search for contexts that might enhance the transmition of useful memes.

Therefore, as a reflexive exercise, I have designed this thesis in the following manner:

Considering the temporal and geographical *spirit* of my context and of this exercise, a Master Degree in Graphic Design and Editorial Practices within the Faculty of Fine Arts of the University of Porto, I found it pertinent to use the academic autonomy of the exercise to inform my progression towards a professionalized practice. However, an academic context shouldn't be thought as an intrinsically autonomous opportunity. The truth is that I paid for this opportunity. I have used the revenues of my work, as a conventional graphic designer, to create this specific opportunity. If it is autonomous it is because I decided so. Even if education was free, which it isn't, it would have been paid by the national collective will, and as such, it would still be an intended

autonomy. Hence, I could say that I gave myself the opportunity to be my own client, and as an assignment I wanted to develop a book to show myself that I could keep on being the client.

To carry out this assignment, I would have to find the necessary arguments to substantiate the idea that not only I could, but that I should strive for this autonomy. Designing memes would be the ultimate motif, relating the practice of editorial design back to communication above persuasion. For this reason, I have decided to write in English, providing the ideas on this book with better fecundity, its capacity to make copies of itself, or better, to have a broader impact on the practice of design. This implied that I was using this temporary autonomous exercise as example for a specific practice of design not only to myself, but to others. I guess all students wish to have some sort of influence with their research. Call it a sell out if you will or an approximation to the popular and mainstream communication, but if I truly wish to create opportunities for a broader set of contexts, I must imperatively attempt a wider communication.

Eventually, I have decided not to include any images. If I was to focus on content, instead of form, the process instead of the result, the absence of any image was a must. I had collected some interesting ones however, like covers of the *Simplicissimus* magazine later issues with Nazi propaganda, aerial photos of *terrils* in the north of France or beautifull spreads for Fletcher's book *The Art of Looking Sideways*. The decision wasn't obvious, but when I removed them it made sense. Besides, they are easily available online and any curious reader will have the urge to search for them. As a result, all necessairy imagery would have to be textually described.

Other decisions were made in accordance this conception. From the very start, I wanted to explore the possibilities offered by different distribution platforms. With that in mind, I have designed the format of the book in accordance to print-on-demand services. Using the Lulu self-publishing platform (www.lulu.com), I have chosen a format that would be eligible for global retail distribution, in this case the "crown quarto", with 18.91 x 24.59 cm. This is probably not the

cheapest way of producing the book, costing around 5€ each print. However, the benefits are considerable, allowing for anyone with an internet connection to order a single digital print without the need of an initial investment for printing a large quantity of units. At the same time, I could order my own prints from there, or send it to someone directly from the printer.

Besides considering the physical reproduction of the book, I considered the possibility of digital reproduction. My initial intention was to develop an e-book, however, that idea was purely formal. It is interesting how it mimics the book by representing spreads and how it allows for a responsive interaction, but I soon understood that the e-book functions mainly as a media for monetising digital publications, and even if there is nothing wrong with that, my intention was to distribute this document free of charge. A Portable Document Format (PDF) proved to be considerably more versatile for the purpose of distribution as the avarage graphic designer is quite used to PDFs. Considering that a PDF will most likely be read one page at a time, instead of a spread of two pages, the layout of the page was defined as central and symmetrical. Moreover, I have deleted the white pages on the PDF – only usefull for the printed verison –, while retaining the same page numbering throughout the document.

More than that, I can only mention the typeface *Naimara* that I drawn during the first year of the Master program, used for the titles in this publication. However, this was for no particle reason, besides the emotional relation I might have with it. Nevertheless, it might function as mark of the subjectivity of this thesis.

After this exercise, I can't say for sure how will I manage to keep an autonomous practice. The challenge seems difficult: how to develop an autonomous practice outside the commercial context. That, I don't know, but at least I am convinced of the importance of trying. The current scarcity of institutional and governmental support for activities that don't fit the economic profitability agenda, together with hard living conditions don't seem to present a favourable condition, but at least I know "how I want to practice design, not how I want to design." (*Ibidem*)

BIBLIOGRAPHY

Baily, Stuart (2001). *Bruce Mau: Life Style*. Retrieved 14.03.2015,
 from www.typotheque.com/articles/bruce_mau_life_style.

Bensaude-Vincent, Bernadette & Newman, William R. (2007). *The Artificial and the Natural: An Evolving Polarity*. Cambridge, MA, MIT Press.

Bierut, Michael (2003). *Graphic Design and the New Certainties*. Retrieved 21.02.2015,
 from designobserver.com/feature/graphic-design-and-the-new- certainties/1617/.

Bierut, Michael (2004). *What is Design For? A Discussion*. Retrieved 09.04.2015,
 from designobserver.com/article.php?id=2507.

Bil'ak, Peter (2004). Contemporary Dutch graphic design: an insider/outsider's view. Retrieved 20.02.2014, from www.typotheque.com/articles/contemporary_dutch_graphic_design.

Blauvelt, Andrew (2013). *Graphic Design: Discipline, Medium, Practice, Tool, or Other?*.
 Retrieved 10.04.2015, from vimeo.com/66385792.

Bruinsma, Max (2004). *Bruce Mau: "Massive Change", e-mail conversation with Max Bruinsma*.
 Retrieved 17.11.2014, from maxbruinsma.nl/change/bottom.html.

Burkhardt, François (1988). *Design and 'avant-postmodernism'*. In *Designing after Modernism*.
 J. Thackara. London, Thames & Hudson.

Candeias, António (1998). *Alfabetização e Escola em Portugal na Transição do Século: Dados e Perspectivas*. Lisbon, Instituto Superior de Psicologia Aplicada.

Darwin, Charles (1859). *On the Origin of Species By Means of Natural Selection,
 or, the Preservation of Favoured Races in the Struggle for Life*. Retrieved 07.10.2014,
 from www.gutenberg.org/ebooks/2009. E-book.

Dawkin, Richard (1976). *The Selfish Gene*. New York, Oxford University Press, 2006.

Dawkins, Richard (1982). *The Extended Phenotype*. New York, Oxford University Press.

Dennet, Richard C. (1992), *Consciousness Explained*. New York, Back Bay Books.

Drucker, Johanna & McVarish, Emily (2009). *Graphic Design History: A Critical Guide*.
 Upper Saddle River, N.J. Pearson Prentice Hall.

Dunne, Anthony (2008). *Hertzian Tales*: *Electronic Products, Aesthetic Experience,
 and Critical Design*. Cambridge, MA, MIT Press.

Dunne, Anthony & Raby, Fiona (2000). Park Interactives. Retrieved 13.03.2015, from www.dunneandraby.co.uk/content/projects/277/0.

Dunne, Anthony & Raby, Fiona (2007). *Critical Design FAQ*. Retrieved 13.03.2015, from www.dunneandraby.co.uk/content/bydandr/13/0.

DuVall, Ben (2014). *As Small a Critical Design as Possible*. Retrieved 15.03.2015, from thequietestnoiseonearth.tumblr.com/post/79444369970/as-small-a-critical-design-as-possible.

Erlhoff, Michael (2008). *Design Dictionary: Perspectives on Design Terminology*. Basel, Birkhäuser.

Flusser, Vilém (1993). *The Shape of Things: A Philosophy of Design*. London, Reaction Books, 1999.

Fuller, R. Buckminter (2010). *Ideas and Integrities: A Spontaneous Autobiographical Disclosure*. Series Editor Jaime Snyder. Basen, Switzerland, Lars Muller Publishers.

Heller, Steve (2003). Merz to Emigre and Beyond: Avant-Garde Magazine Design of the Twentieth Century. London, Phaidon.

Helvetica. Gary Hustwit. Swiss Dots, 2007. Documentary.

Hollis, Richard (2001). *Graphic Design: a concise history*. London: Thames & Husdon.

Kirby, Alan (2006). *The Death of Postmodernism And Beyond*. In *Phylosophy Now*. Retrieved 08.04.2015, from philosophynow.org/issues/58/ The_Death_of_Postmodernism_And_Beyond.

Kupferschmid, Indra (2012). *Some notes on the history of Akzidenz-Grotesk*. Retrieved 14.03.2015, from kupferschrift.de/cms/2012/04/ag/.

Kyes, Zak & Owens, Mark (2007). Forms of Inquiry. Retrieved 13.03.2015, from formsofinquiry.com/.

Laranjo, Francisco (2014). *Critical Graphic Design: Critical of What?*. Retrieved 13.03.2015, from designobserver.com/feature/critical-graphic-design-critical-of-what/38416/.

Lyotard, Jean-François (1984). The Postmodern Condition: A Report on knowledge. Retrieved 12.06.2015, from www.abdn.ac.uk/idav/documents/Lyotard_-_Postmodern_Condition.pdf.

Lloyd, Seth (2006). *Programming the Universe: A Quantum Computer Scientist Takes on the Cosmos*. New York, Vintage Books.

Lloyd, Seth (2008). *Life: What a concept!*. Retrieved 10.09.2014,
from edge.org/event/life-what-a-concept.

Lupton, Ellen (2004). *Thinking with Type*. New York, Princton Architectural Press.

Marxist Internet Archive. Retrieved 18.06.2015,
from www.marxists.org/glossary/terms/s/p.html.

McKibben, Bill (1989). *The End of Nature*. New York, Anchor Books.

Meggs, Philip B. & Purvis, Alston W. (2011). *Meggs's History of Graphic Design*.
New York, John Wiley & Sons.

Metahaven (2013). *Can jokes bring down governments?*. Streak Press. E-book.

Mills, C. Wright. (1958). *Man in the middle*. In *The Politics of Truth — selected writings of C Wright Mills*. John H. Summers. New York, Oxford University Press.

Mitchell, Tom (1988). *The product as illusion*. In *Designing after Modernism*. J. Thackara.
London, Thames & Hudson.

Moura, Mário (2001). *O Big Book: Uma Arqueologia do Autor no Design Gráfico*. Doctoral Thesis.
Porto, FBAUP.

Norberg-Schulz, Christian (1980). *Genius Loci: Towards a Phenomenology of Architecture*.
New York, Rizzoli.

Popper, Karl (1945). *The Open Society and Its Enemies* (Vol II).. Retrieved 18.04.2015,
from archive.org/stream/opensocietyandito33064mbp#page/n5/mode/2up.

Poynor, Rick (1999). *First Things First Revisited*. Retrieved 25.10.2014,
from www.emigre.com/Editorial.php?sect=1&id=13.

Poynor, Rick (2008). *Critical Omissions*. Retrieved 17.04.2015
from www.printmag.com/article/observer_critical_omissions/.

Rawsthorn, Alice (2013). *Hello World: Where Design Meets Life*. London, Hamish Hamilton.

Rock, Michael (1996). *The Designer as Author*. Retrieved 24.02.2015,
from www.eyemagazine.com/feature/article/the-designer-as-author.

Sauer, Carl O. (1916). *Man's Influence Upon the Earth*. In *Carl Sauer on culture and landscape: readings and commentaries*. William M. Denevan & Kent Mathewson. Baton Rouge, Louisiana State University Press.

Scher, Paula (2010). *Interview for pr*tty sh*tty blog*. Retrieved 24.05.2015, from prttyshttydesign.blogspot.pt/2010/02/ps-interviews-ps.html.

Sisson, Patrick (2015). *Bruce Mau leads design brainstorm by encouraging leaps in thought*. Retrieved 04.05.2015, from www.chicagotribune.com/bluesky/originals/chi-bruce-mau-design- innovation-bsi-story.html.

Smith, Gillian Crampton (1998). *Foreward*. In *Hertzian Tales: Electronic Products, Aesthetic Experience, and Critical Design*. A. Dunne. Cambridge, MA, MIT Press.

Sueda, Jon & Bailey, Stuart (2006). *Stuart Bailey Speaks Up*. Retrieved 14.04.2015, from www.underconsideration.com/speakup/interviews/bailey.html.

Twemlow, Alice (2008). *Some Questions about an Inquiry*. Retrieved 18.03.2015, from designobserver.com/feature/some-questions-about-an-inquiry/6577/.

United Nations, Department of Economic and Social Affairs, Population Division (2014). *World Urbanization Prospects: The 2014 Revision*. Retrieved 12.03.2015, from esa.un.org/unpd/wup/Highlights/WUP2014-Highlights.pdf.

Various Authors (1964). *First Things First. A manifest*. Retrieved 20.10.2014, from maxb.home.xs4all.nl/ftf1964.html.

Various Authors (2000). *First Things First. A design manifest*. Retrieved 20.10.2014, from maxb.home.xs4all.nl/ftf2000.html.

Velden, Daniël van der (2006). *Research & Destroy. Graphic Design as Investigation*. Retrieved 19.04.2015, from metropolism.com/magazine/2006-no2/research-destroy/english.

Vermeulen, Timotheus & Akker, Robin van den (2010). *Notes on Metamodernism*. Retrieved 11.05.2015, from www.aestheticsandculture.net/index.php/jac/article/view/5677.

Vogel, Steven (2003). *The Nature of Artifacts*. In *Environmental Ethics*, 25(2), pp. 149-168.

"Zeitgeist". Oxford Dictionary of English (2013). Oxford University Press

www.ingramcontent.com/pod-product-compliance
Lightning Source LLC
Chambersburg PA
CBHW080229180526
45158CB00008BA/2304